Puint a watercolour landscape in minutes

BUILDINGS, BRIDGES
and WALLS

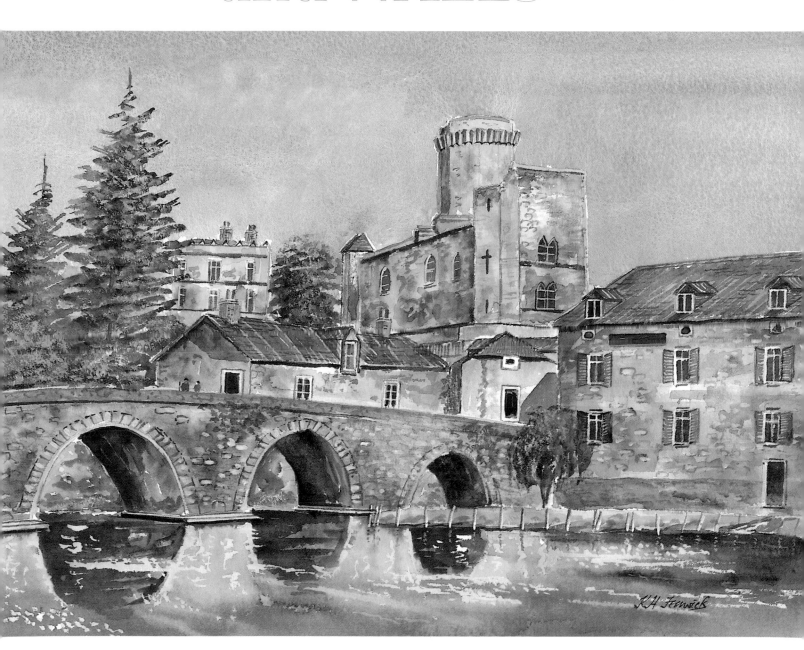

Keith Fenwick

BUILDINGS, BRIDGES and WALLS

Dedication:

To Dorothy, my wife, for her support, advice and typing of the text, and to all my students over the years whose needs have helped me to determine the content of this book.

Distributed to the trade and art markets in North America by North Light Books
an imprint of F & W Publications, Inc.
4700 East Galbraith Road
Cincinnati, OH 45236
(800) 289-0963

ISBN 1-58180-393-1

WINSOR & NEWTON, COTMAN, FINITY, SCEPTRE GOLD, WINSOR and the GRIFFIN device are trademarks of ColArt Fine Art & Graphics Limited.

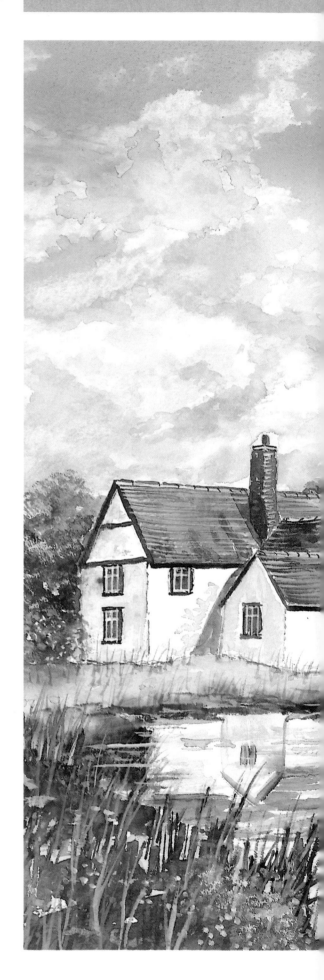

FOREWORD

The story of Winsor & Newton is one of partnership, between our founders starting in 1832 and subsequently between our company and artists. For this reason the name Winsor & Newton has become synonymous with fine art materials throughout the world. The foundation of the company stems from the development and introduction of the world's first moist watercolours in the 1830s – to this day we are justly proud of the pre-eminence around the world of our range of watercolours and materials.

Watercolour artists, from beginners to professionals, will now have the opportunity to both develop their artistic skills and their familiarity with the Winsor & Newton range through this exciting new series of techniques books, written and illustrated by the highly respected artist and instructor Keith Fenwick.

Throughout its long and successful history, the Winsor & Newton brand has developed a proud tradition of producing fine art materials of the highest quality – the company is delighted to witness the publication of a range of watercolour books that achieves similarly high levels of quality and innovation.

CONTENTS

BUILDINGS, BRIDGES and WALLS

INTRODUCTION

Watercolour is an ideal medium for painting structures, because of its transparent qualities, which enable the artist to work wet into wet to capture the effects of weathering and texture, and to paint simple washes to indicate the effects of light.

I have attempted to cover a wide range of subject matter in this book. In addition to guidance on how to paint a variety of buildings, bridges and walls, I have included basic instruction on the art of drawing and the principles of perspective. This instruction is fundamental if you want the structures in your paintings to look realistic.

I always travel with a sketch-book, a tin of water-soluble crayon and a camera. These tools enable me to make quick sketches or coloured 'doodles' or take photographs of any interesting structures that I come across. Over the years I have built up a large resource on which I am able to draw for ideas for compositions.

Whatever you plan to include in your landscape, it's important to organize your subject in accordance with the principles of good design – tonal values, variation, gradation, contrast, counter-change, balance, colour harmony or perspective. I shall give you advice on all these topics.

Read on and I will show you how easy it can be to capture the essence of buildings, bridges and walls in your paintings.

Enjoy your painting.

Keith H Fenwick

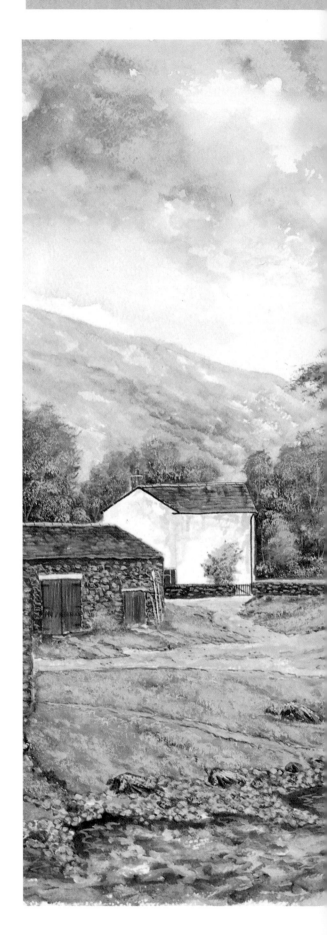

4

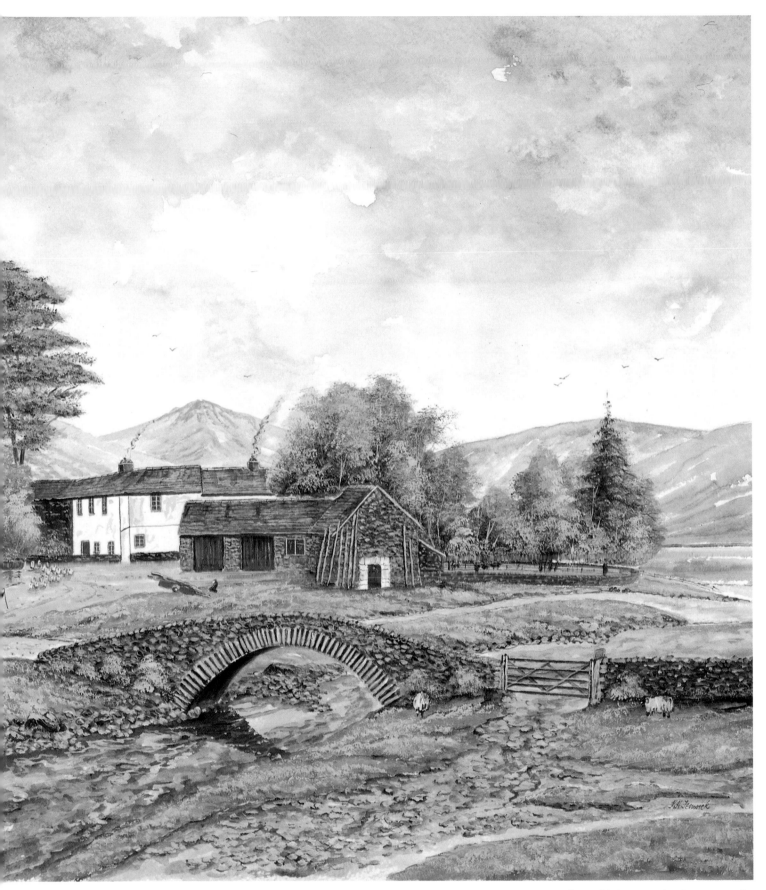

The old hamlet of Watendlath in the English Lake District epitomizes the character of the area, with its old farmsteads, famous pack-horse bridge spanning the river and the tarn (small lake). Sir Hugh Walpole included the hamlet in his family saga 'The Herries Chronicle'.

INTRODUCTION

A visit to the local art store can be a confusing experience. My preference is to use quality materials, and I would advise you to do the same. Purchase the best you can afford. It will work out cheaper in the long run and save you a great deal of frustration.

PAINTS

You will find that most professional artists prefer tube colours because they are moist and more convenient for mixing large washes of colour. If they are left unused, pans of paint become very hard and release less paint.

The choice of colours is personal to the artist, but you won't go far wrong if you begin with my basic range. This comprises:

SKY	Payne's Gray	BRICKWORK	Raw Sienna
	Cerulean Blue		Burnt Sienna
	Alizarin Crimson		Vermilion
			Cobalt Blue
EARTH	Raw Sienna		
	Burnt Sienna	SHADOWS	Alizarin Crimson
	Burnt Umber		French Ultramarine
			Raw Sienna
STONEWORK	Raw Sienna		Burnt Umber
	Burnt Sienna		
	Cobalt Blue	MIXERS	Cadmium Yellow Pale
	Alizarin Crimson		Permanent Sap Green

PALETTE

All artists have their own way of painting. I prefer to use a large open palette. I simply draw my colours into the centre of the palette and mix them to my requirements. For large washes I premix colours in saucers. The palette shown includes a lid which provides more than ample space for mixing colours.

BRUSHES

For painting skies and other large areas, I use a 1½in hake brush and for control a size 14 round. For buildings and angular elements, such as mountains and rocks, I use a ¾in flat. For fine detail, such as tree structures, I use a size 3 rigger (originally developed for painting ships' rigging, hence the name) and for detailed work, shadows etc, I use a size 6 round.

PAPERS

Quality papers come in different forms, sizes, textures and weights. Paper can also be purchased in gummed pads, spiral bound pads, blocks (glued all around except for an area where the sheets can be separated) and in varying sizes and textures.

I prefer to purchase my paper in sheet form (30in x 22in) and cut it to the appropriate size. The paintings in this book were painted on 200 or 300lb rough textured watercolour paper. When sketching outdoors, I use spiral bound pads.

Winsor & Newton offer a choice of surfaces and weights, as follows:

HP (Hot pressed) has a smooth surface, used for calligraphy and pen and wash.

NOT (Cold pressed) has a slight texture (called 'the tooth') and is used for traditional watercolour paintings.

ROUGH paper has a more pronounced texture which is wonderful for large washes, tree foliage, sparkle on water, dry brush techniques, etc. I always use a rough textured paper.

Paper can be purchased in different imperial weights (the weight of a ream (500 sheets), size 30in x 22in):

90lb/190gsm is thin and light; unless wetted and stretched, it cockles very easily when washes are applied.

140lb/300gsm paper doesn't need stretching unless very heavy washes are applied.

200lb/425gsm or 300lb/640gsm papers are my preference.

OTHER ITEMS

The following items make up my painting kit:

Tissues: For creating skies, applying textures and cleaning palettes.

Mediums: Art Masking Fluid, Permanent Masking Medium, Granulation Medium and Lifting Preparation are all useful and selectively used in my paintings.

Masking tape: To control the flow of paint, masking areas in the painting and for fastening paper to backing board. I prefer ¾in width as it is easier to remove.

Cocktail sticks: Useful for applying masking when fine lines are required.

Grease-proof paper: For applying masking.

Atomizer bottle: For spraying paper with clean water or paint.

Painting board: Your board should be 2 inches larger all round than the size of your watercolour painting. Always secure your paper at each corner and each side (8 places) to prevent it cockling when you are painting.

Eraser: A putty eraser is ideal for removing masking.

Sponge: Natural sponges are useful for removing colour and creating tree foliage, texture on rocks, etc.

Water-soluble crayons: For drawing outlines, correcting mistakes and adding highlights.

Palette knife: For moving paint around on the paper (see page 32).

Saucers: For mixing large washes and pouring paint.

Hairdryer: For drying paint between stages.

Easel and stool: I occasionally use a lightweight easel and a stool for outdoor work.

PAINTING BUILDINGS *Introduction*

The subject of buildings covers a very wide field. Because they come in a variety of shapes and forms, buildings offer the watercolourist an exciting range of opportunities. In this book, I have attempted to reflect this range by showing you my approach to painting many different types of building, from old farmsteads to medieval castles.

I am fascinated by the structure of buildings and the textures you find in them. An interesting window, an old door with rusty hinges, a stairway or an element in a street scene with people, all are worthwhile subjects. You don't have to paint a complete landscape to get a rewarding watercolour.

To paint buildings well, it's important to be able to sketch and draw reasonably accurately to represent the scene effectively. I felt it was necessary, therefore, to include in the text some basic instruction on how to draw. Drawing isn't difficult, just common sense, but there's an approach to drawing that I follow, which I will explain in the following pages.

Perspective plays an important part in drawing buildings. Some people find perspective easy, other people don't. Fortunately, I have never experienced problems with it. If you do, don't worry. I intend to simplify perspective for you later in the book.

Paintings don't just happen, they have to be designed. And if you learn how to do this your end result won't be just a matter of luck. You will discover that you must establish a plan using your imagination, asking yourself what the main features in your chosen picture are and how you can emphasize them. Tonal values, colour, texture and contrast all play a part in this. In the exercises and demonstrations in this section, I will be describing and showing how all this is done.

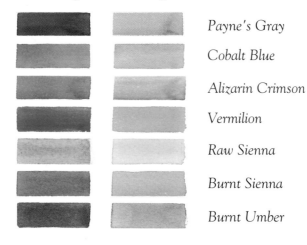

Payne's Gray

Cobalt Blue

Alizarin Crimson

Vermilion

Raw Sienna

Burnt Sienna

Burnt Umber

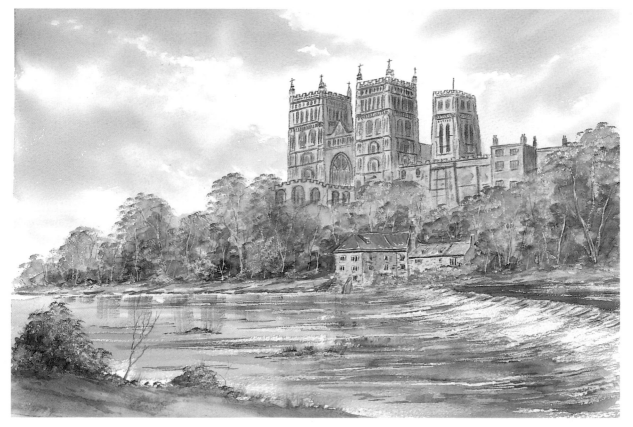

*Majestic **Durham Cathedral**, overlooking the River Wear in the north of England, makes a lovely scene to paint.*

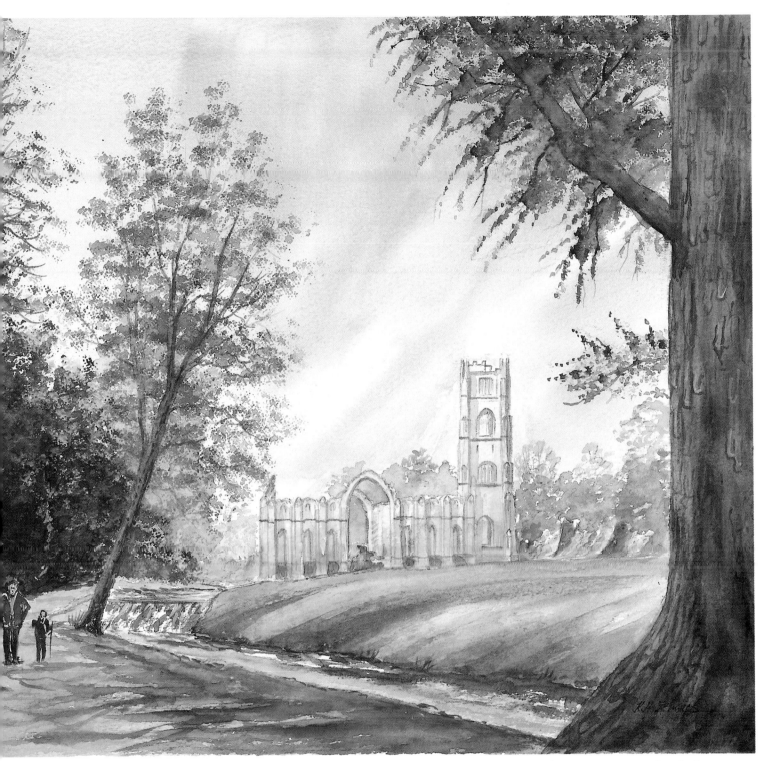

Fountains Abbey in Yorkshire. When I painted this scene the sun was shining on the abbey, throwing it into stark relief against the heavy shadows in the trees and across the path.

Practice

- Study the examples in this book and practise painting wet into wet skies to represent the various light situations.
- Practise colour mixing, using the colours specified in the text.
- Practise using an eraser to remove colour, creating shafts of light as in a woodland glade or an atmospheric sky.

BUILDINGS, BRIDGES and WALLS *Sketching on location*

There's no substitute for sketching and drawing. No matter how good you are at applying paint, if your initial drawing is out of scale and your perspective is wrong the end result will be a failure. Draw, draw and more drawing is the answer.

The sketches I produce when on location are not intended to be masterclass drawings but quick doodles to act as a record of my visit to an area or as a simple outline direct on to watercolour paper ready for applying paint at a later date. The amount of detail you include in your sketches or outline drawings and the techniques you use to create texture will depend on the particular subject, the time available for drawing or the intended use of the finished work. Knowing when to stop will come with experience.

Sketching and drawing is a pleasant relaxing experience which forces you to think about your subject and observe it very closely. When you have been sketching and drawing for some time you will no longer think about your style but concentrate on the statement you are trying to make.

Windmills near Amsterdam.

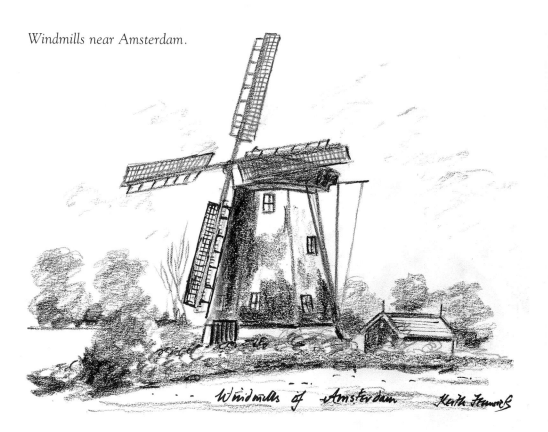

Windmills of Amsterdam Keith Fenwick

Drawing Materials

How you interpret your subject is personal, whether you use pencil, crayon, charcoal, conté crayon, felt tip pen or drawing pen and ink. My personal choice includes 4B and 6B pencils, water-soluble crayons or drawing pens (sizes 0.5 and 0.7mm). For both pencil and pen work, I like to use 2 ply Bristol board which has a bright white surface. When using water-soluble crayons, I find the fine texture of an oil or acrylic painting pad is perfect for creating shading and textures speedily.

Approaches to Sketching

I find many of my students just want to paint and ruin a perfectly good piece of watercolour paper without spending the time observing their subject, simplifying the scene, studying the relationships of darks and lights, the direction of light and shadows and the scale of the various elements in the scene.

The time spent drawing provides you with thinking time, the opportunity to produce several sketches to help establish the best viewing point to determine the best composition. Try to spend three minutes observing and thinking to every minute drawing or painting.

Use of a Viewfinder

We all have our likes and dislikes – what we sketch is that which appeals to us and how we feel about the subject at the time. A viewfinder can help us to select what appeals to us. It is useful for identifying potential scenes from different viewpoints, and helps to establish the best composition. It's very easy to make your own viewfinder which you can cut from a piece of mounting card. The one I use has an aperture of 4½in x 3in.

When you view a scene, get into the habit of looking at what's before your eyes in terms of the lines, colours, textures, tonal values, shapes and contrasts they present. Don't think of what is there as being buildings, trees, mountains, or whatever it happens to be. That approach will only limit your imagination.

Quick Sketching

When visiting an area I produce quick sketches, supplemented by photographs, from which I can produce a completed painting on my return to my studio. Sketching and drawing on location with limited time sharpens your observation of the scene. It encourages you to simplify, discarding unnecessary detail that doesn't contribute significantly to the overall representation.

Squinting one's eyes to view the subject helps to establish the lights and darks, eliminating unnecessary detail. As an artist you must create your own composition using your imagination and skills to simplify and organize your subject in accordance with the principles of good design.

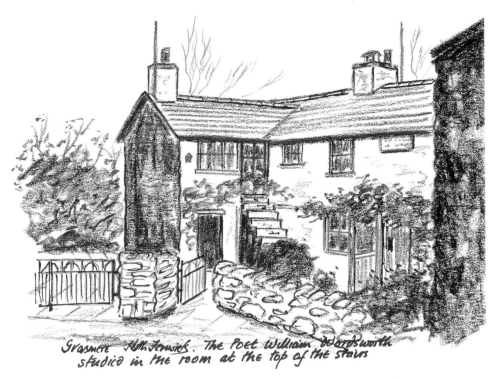

The poet Wordsworth's home at Grasmere in the English Lake District.

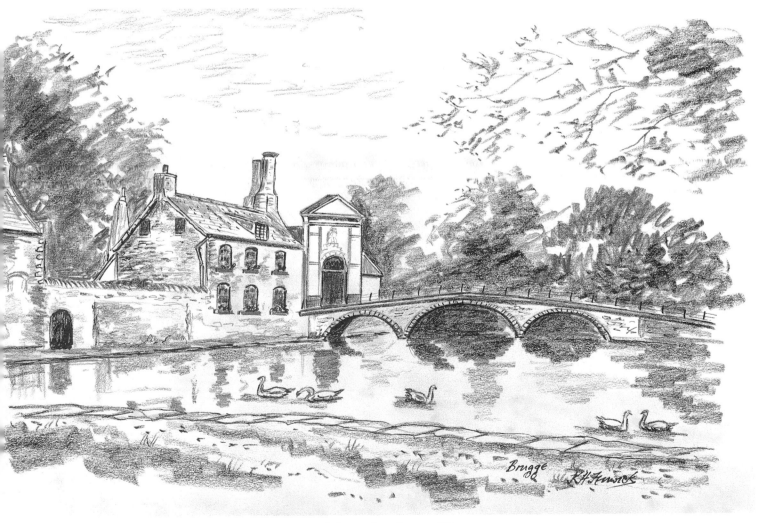

A view of the medieval city of Bruges.

The initial black and white sketch or drawing is an important aspect of planning before you begin applying watercolour. Through your tonal studies you can determine the most attractive composition and work out your values and shapes. Use artistic licence, if necessary, to improve your composition. Simplify and prepare your drawing loosely or in detail. I personally prefer to draw on to my watercolour paper with a dark brown water-soluble crayon because I do not like to see pencil marks in a finished painting. When I draw faintly with the crayon and apply my watercolour washes, the lines will wash out.

Both sketches were drawn with a drawing pen and shaded with a water-soluble crayon.

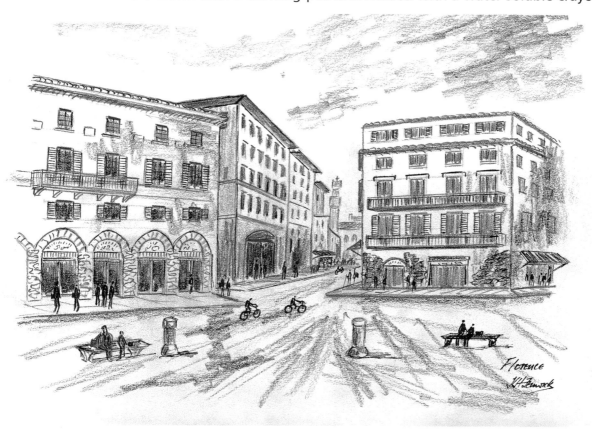

Drawing a Street Scene
For this street scene, follow the same procedure as that given for drawing the Grand Canal opposite. Take particular care getting the perspective of the roofs, footpaths and windows right. Each block of buildings has a different vanishing point.

Getting the size right

Drawing isn't difficult providing you follow a logical procedure. When drawing a complex scene, where a significant number of buildings is involved, always use a piece of watercolour paper that is larger than is actually required.

Draw in your buildings and then trim your painting to size. There's nothing more frustrating than starting your drawing and running out of paper before you've drawn all of the buildings. Using a larger sheet and trimming to size until you've mastered the art of drawing to scale will avoid the frustration of having to rub out and virtually begin again.

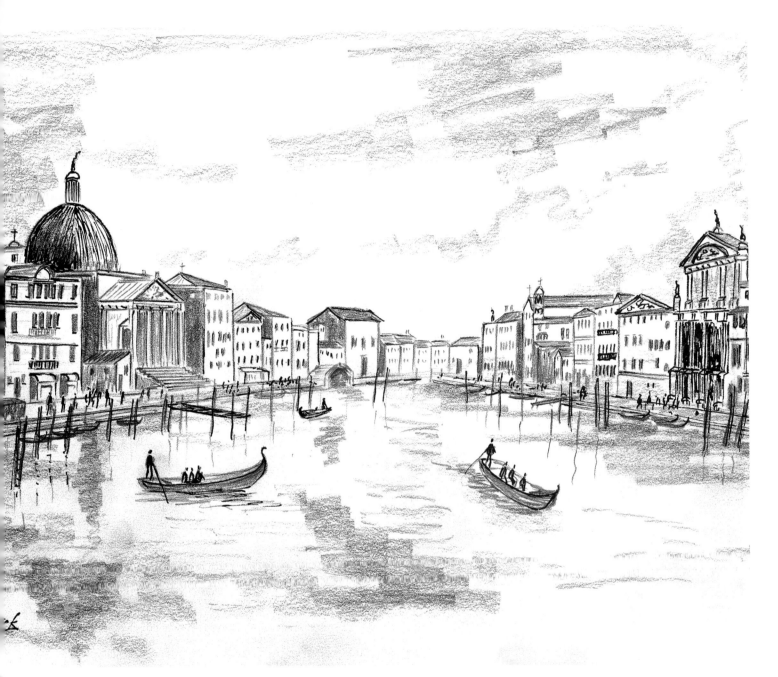

Drawing the Grand Canal, Venice

When drawing any group of buildings, there's a logical procedure I follow. If you adopt this approach you will be able to draw most scenes realistically. The procedure:

• Commence by establishing the angles of the water levels and the vanishing point.

• Draw one building in the scene first, making sure the height of the building is in proportion to its frontage.

• Draw in the vertical lines of all other buildings, taking care that the length of frontage of each building is in proportion to that of the adjoining buildings.

• Draw in the height of each building in proportion to its frontage and the height of its neighbours.

• Hold your pen or pencil at arm's length and line it up with the angle of the roof, moving your arm down-towards your paper to determine the correct linear perspective.

• Finally, draw in the windows, steps, balconies, etc.

It's as easy as that. Following this logical procedure will ensure that your buildings are drawn to scale in the correct proportions. If your buildings are out of proportion and your perspective is incorrect, no matter how good you are at applying paint the result won't be pleasing.

PAINTING BUILDINGS *Project*

Under a Norfolk Sky provided me with the opportunity to show how to paint an atmospheric sky and to include a windmill, one of many to be discovered in this eastern region of England. This is a very simple exercise for you to try. For the painting to work the atmospheric sky is essential.

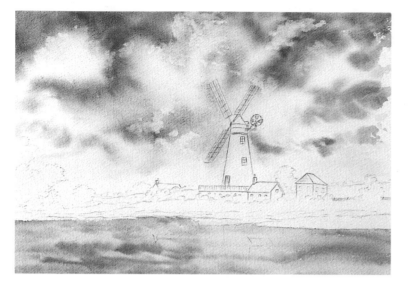

1. SKY

I used a water-soluble crayon to draw the windmill, buildings and riverbank. The sky was painted using a 1½in hake brush by initially wetting the paper with a very pale Raw Sienna and brushing in the dark clouds using mixes made from Cerulean Blue, Payne's Gray and Burnt Sienna.

Circular movements of the brush were used to create the impression of cumulus clouds, working around light areas. Larger clouds were created at the top of the painting and smaller clouds approaching the horizon to achieve linear perspective.

The same colours used for the sky were used to paint the water.

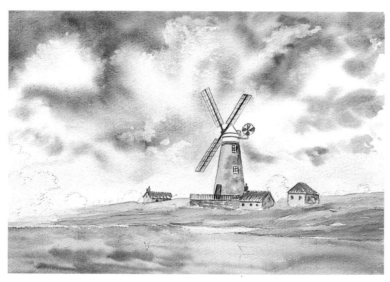

2. WINDMILL

The windmill tower was painted by initially applying a Raw Sienna wash and whilst still wet brushing in some Burnt Sienna and a Payne's Gray/Cerulean Blue mix, allowing the colours to spread and blend together.

The red roofs of the buildings were painted with a ¾in flat brush loaded with a mixture of approximately 20 per cent Alizarin Crimson and 80 per cent Burnt Sienna. The brickwork at the base of the windmill and the door were painted using this same mix. The walls of the buildings were painted using the same colours and techniques used to paint the windmill tower.

Finally the windmill blades and safety fencing were painted using a rigger brush, and the grass painted using a variety of greens.

3. TREES

It's time to paint the trees and bushes using a mixture of greens made from Cadmium Yellow Pale, Raw Sienna, Permanent Sap Green and Payne's Gray. A round hog-hair oil painter's brush was used to stipple in the foliage, taking care to ensure a variety of tree shapes and heights. I used a palette knife to scratch in some tree structures. Some darker tones were used to emphasize the edge of the riverbank.

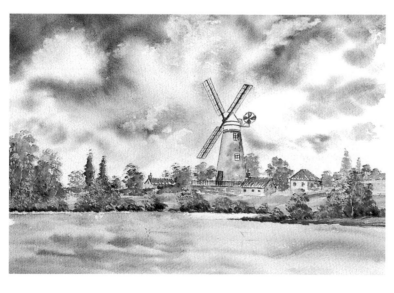

Payne's Gray Alizarin Crimson Raw Sienna Cerulean Blue

Cadmium Yellow Pale Permanent Sap Green Burnt Sienna

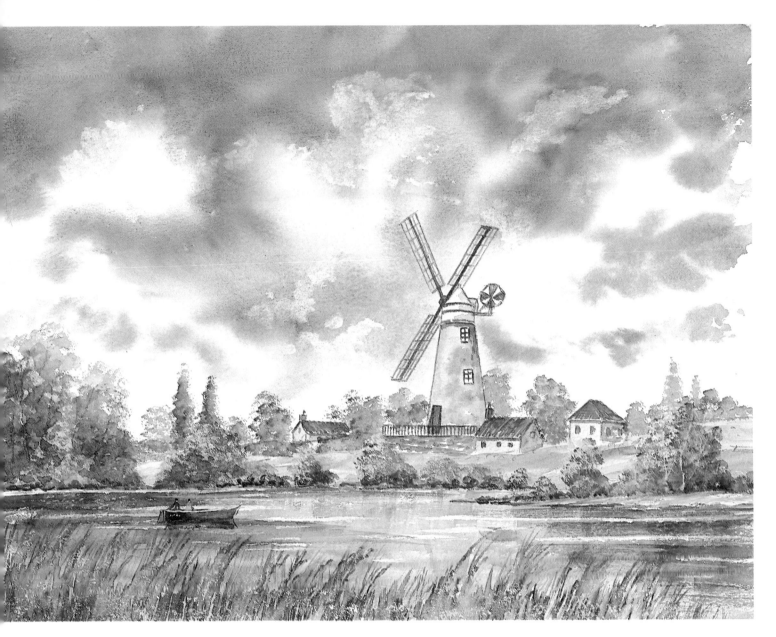

4. REFLECTIONS AND FOREGROUND

It's time to bring the painting together and add the finishing touches. Raw Sienna, Cadmium Yellow Pale and Burnt Sienna glazes were applied to the foliage and tree structures. These same glazes were also used to colour the rocks and create depth of tone.

Highlights to the foliage were then applied. Paper masks had to be first cut to shape to protect other areas, such as the sky; I used a piece of mounting card cut to various profiles to fit around the trees. To apply the paint, I took an old toothbrush, dipped it in Cadmium Yellow Pale, ran my thumb over the bristles and then spattered the colour onto the foliage.

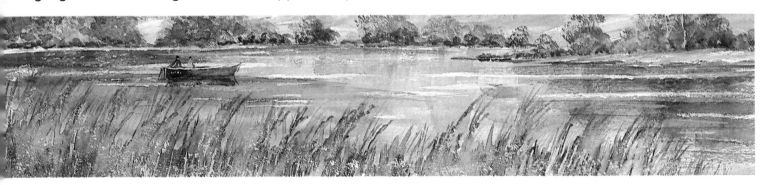

BUILDINGS, BRIDGES and WALLS *Linear perspective*

When drawing buildings, perspective is an important consideration if you want to make your drawing look believable. Most of my students find perspective difficult. Let's see if we can simplify the subject.

Where your eye meets the horizon is called the eye level. This imaginary line is a straight horizontal line which will naturally change as you lower or elevate your viewpoint.

In the first diagram we are looking straight at our subject from a viewpoint slightly to the left, enabling us to see the gable end of the building. The lines of the roof, windows and ground level converge to one point on the right; this is known as the 'vanishing point'. Because we can see the end of the building, all lines will converge to a vanishing point on the horizon line to the left; this is known as two-point perspective.

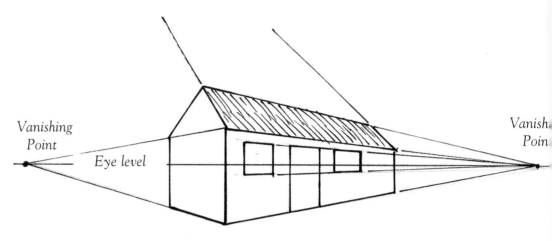

In the second diagram we are looking down at our subject. Our eye level is higher than the building. The same principles apply, though.

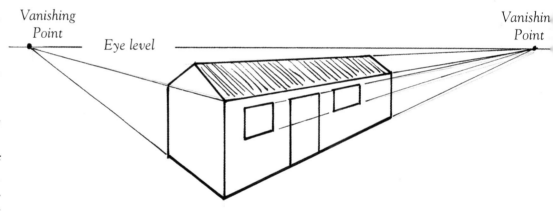

When painting outdoors all you have to do is hold a pen or pencil directly in front of you and line it up with the top of the roof. Move your arm down to your paper and draw in the angle. Repeat this process with other parts of the building to establish the correct perspective.

An even simpler technique is to cut yourself an aperture from a piece of mounting card and position some elastic bands around the perimeter. View your subject through the viewfinder. Line up the elastic bands with various elements of the building (ie. roof, windows, base, etc.) and, transferring this to your paper, draw along the elastic bands to ensure the correct linear perspective.

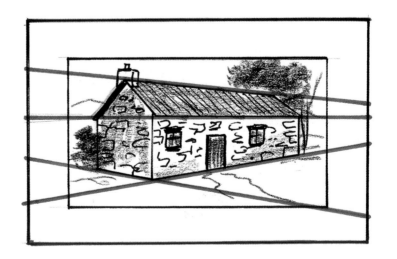

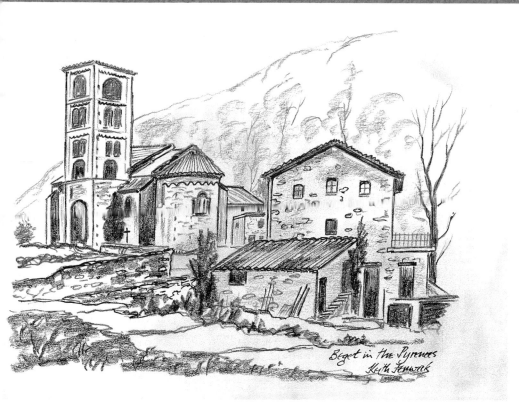

Note the perspective in this quick sketch of the old village of **Beget in the Pyrenees**. The angles at the top of the tower in particular are good examples of linear perspective.

This sketch of **The Creek near Salcombe** in Devon, England was a lovely scene to draw and paint. My students found the perspective quite challenging. The roofs of the thatched cottages highlight the need for the perspective to be correct if the sketch is going to work.

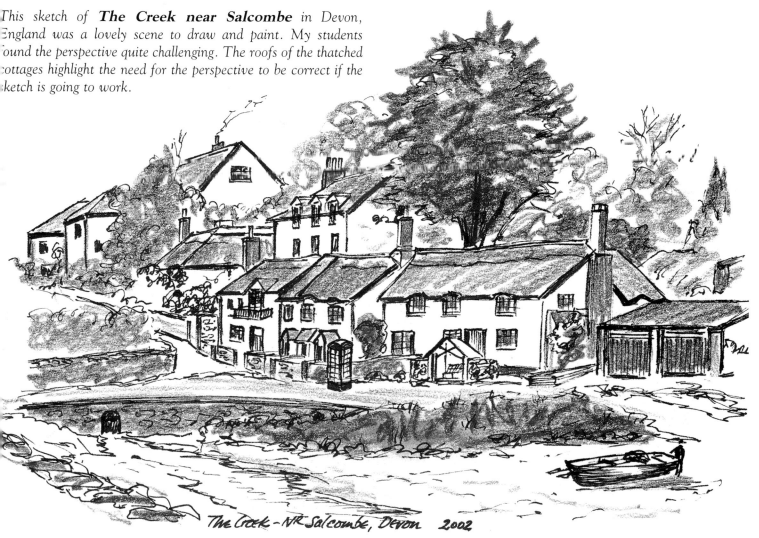

The Creek – Nr Salcombe, Devon 2002

BUILDINGS, BRIDGES and WALLS *Creating textures*

One of the beauties of watercolour is its transparency, making it an ideal medium to create textures on buildings. Buildings come in many shapes and sizes and offer the artist numerous exciting features to paint. The rough texture of stonework, the watermarks, cracks crumbling plaster and weathered exteriors can all make fascinating subjects to capture in watercolour, using a limited range of colours.

The texture on the stonework surrounding this window in Brittany was painted by initially applying white and dark brown oil pastels to areas of white paper. A Raw Sienna wash was applied to the whole of the stonework and while it was still wet, Burnt Sienna and a Payne's Gray/Alizarin Crimson mixture was selectively applied to the stonework. The deposits of oil pastel repelled the watercolour washes, creating the textured effect. Finally, the shadows around the individual stones were emphasized using various tones of Payne's Gray.

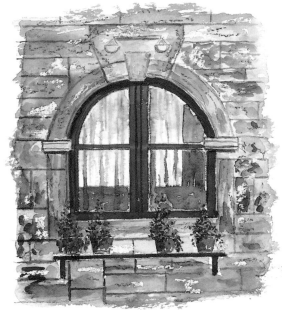

Window in Morbihan - Brittany

Image of Provence

I have attempted to capture the weathered exterior of this old apartment in Provence by initially wetting the paper with a pale Raw Sienna wash and while this was still wet dropping in some Burnt Sienna and a Payne's Gray/Cobalt Blue mixture. The colours have been allowed to blend together wet into wet. A size 6 brush used to move colour to create the effect of weathering.

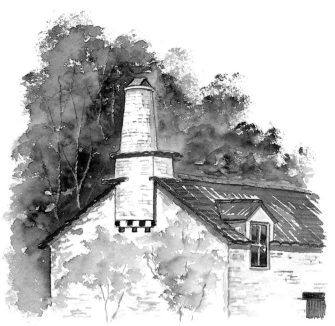

Round chimney - the sign of an old building - note the dovecote

I was fascinated with this old building in the English Lake District. The round chimney signifies its age. Note too the dovecote at the base of the chimney, leading in to the roof area. The originally brick building was painted white and weathering had created some surface stains. I applied a weak Cobalt Blue wash to selected areas and when this was dry I indicated brickwork using a rigger brush loaded with a Payne's Gray/Cobalt Blue mix. Note how the bricks on the chimney were drawn at a slight curve to indicate the round chimney.

The dormer window, which fits into the roof, is a subject often drawn incorrectly.

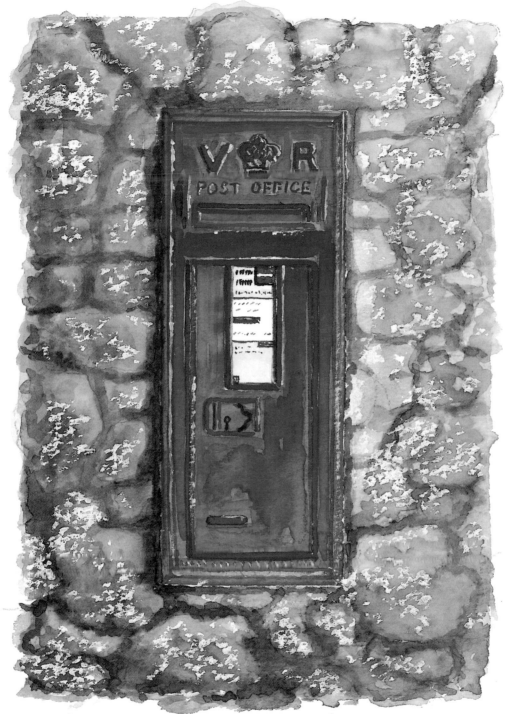

Victorian Postbox at Wasdale Head

I couldn't resist painting this old Victorian postbox housed in a rough stonewall in the hamlet of Wasdale in the English Lake District. The postbox was painted using various tones of an Alizarin Crimson/Vermilion mix to look realistic.

The texture on the stonework was achieved by initially drawing the outlines of the stones and making deposits with both white and cream oil pastels. A Raw Sienna wash was applied overall and splashes of Burnt Sienna and a mix of Payne's Gray/Alizarin Crimson applied wet into wet. An absorbent tissue was used to lighten the stonework by dabbing to remove paint. The shadows around the stones were painted in last. The oil pastel repelled the watercolour paint, resulting in a weathered textured appearance.

Colour is a continuous source of fascination to artists. Colour and light are what we first see when we look at the landscape. When painting buildings, I use few colours, finding that I am able to capture most building structures using a limited palette consisting of Raw Sienna, Burnt Sienna, Burnt Umber for stonework, supported by Payne's Gray, Alizarin Crimson and Cobalt Blue for shadows, watermarks, weathered plaster, etc. and for brickwork, I may introduce Vermilion. The blues I find useful are Cobalt Blue, French Ultramarine or Cerulean Blue, depending on the light.

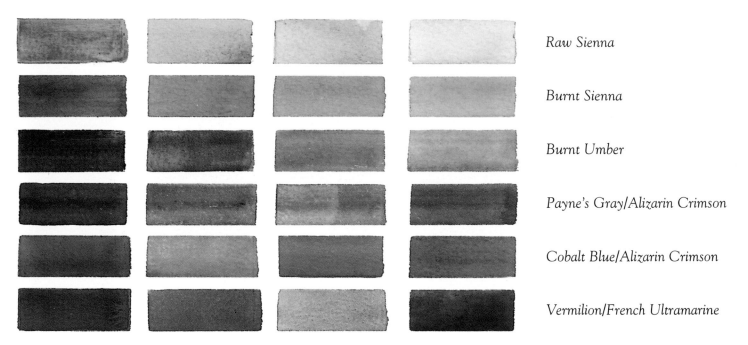

Raw Sienna

Burnt Sienna

Burnt Umber

Payne's Gray/Alizarin Crimson

Cobalt Blue/Alizarin Crimson

Vermilion/French Ultramarine

Check List

- Produce tonal studies to establish the best viewpoint and to determine the relationship between the lights and darks.

- Don't forget to get your perspective correct or your buildings won't look right.

- Don't include elements in your paintings that aren't characteristic of the region

- Great designers simplify and eliminate.

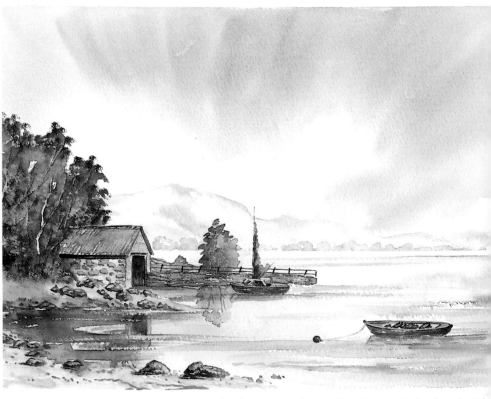

In **Early Morning on the Lake** *the background is diffused with little detail. The boat in the foreground was included to balance the grouping of dark trees on the left of the painting.*

It has always been my practice to produce simple sketches or tonal value studies to determine the ideal viewpoint giving the most pleasing composition. These are simple 'doodles' produced in a few minutes and showing little detail. Approximately 3in x 2in in size, they help me think about my approach to the painting prior to applying paint.

They are my plan of action, helping me to establish the dominant tonal values and the areas of greatest contrast. They help me to plan my approach to the painting, encouraging me to observe and simplify. I use a dark brown water-soluble crayon to produce my tonal studies. I cannot over emphasize the importance of establishing the relationships between the lights and darks in a painting.

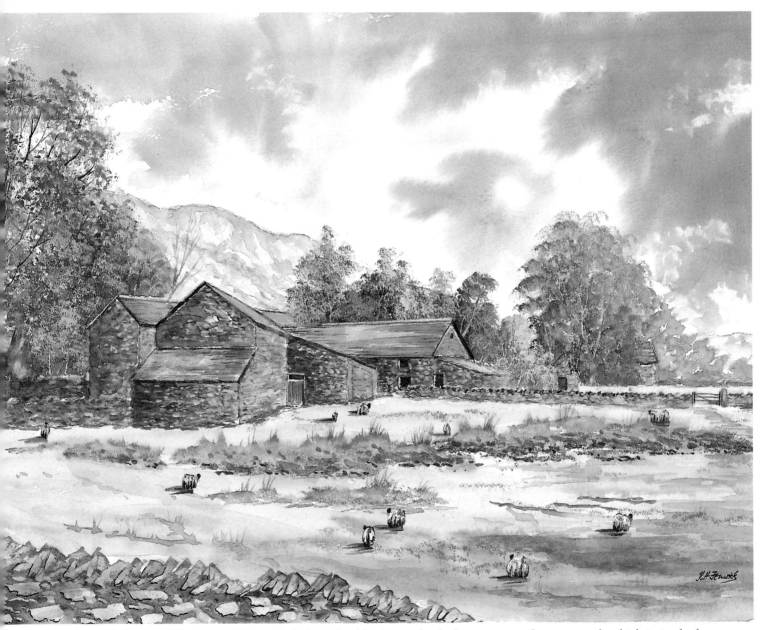

*The subject here, **Lakeland Farm at Mungrisdale**, is backlit. Note the darker tones on the stonework which is in shadow.*

EXERCISES

• Work through the demonstrations until you feel confident to produce your own compositions.
• Travel with a sketch book and produce as many drawings as it takes for you to draw buildings easily.
• Study lots of buildings – note the angles of roofs and their structural lines and practise drawing them until you

have mastered the principles of linear perspective and can produce realistic drawings incorporating them.
• Select an interesting dormer window. Note how it fits into the roof.
• Choose a weathered wall or unusual doorway and sketch and paint its features.

PAINTING BUILDINGS *Close up*

Cape Town's famous waterfront, with its restaurants, shopping mall, bustling harbour and magnificent Table Mountain as a backdrop, was irresistible as a subject for painting while I was on a recent trip to South Africa. I painted the scene shown here later in my studio from sketches and photographs taken from a boat at sea.

SKY AND MOUNTAIN

The simple sky was painted with a mix of Cobalt and Cerulean Blue. Darker washes were applied top left to provide some gradation of colour. A tissue was used to remove paint, indicating a few wispy white clouds. Table Mountain was painted by applying various tones of a Payne's Gray/Cerulean Blue mix over a Raw Sienna underpainting and creating highlights with a tissue shaped to a chisel edge.

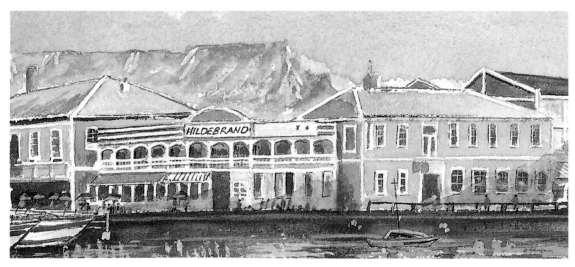

BUILDINGS

The buildings were drawn in lightly with a 4B pencil and masking fluid applied to windows, doors, balconies, parasols and boats. When dry various washes of Raw Sienna and Payne's Gray were applied. When these washes were dry, the masking was removed and the parasols and boats painted.

Perspective

Spend some time drawing to scale to enable you to get the proportions of each building right. Ensure your perspective is reasonably accurate, otherwise your finished painting will be a failure.

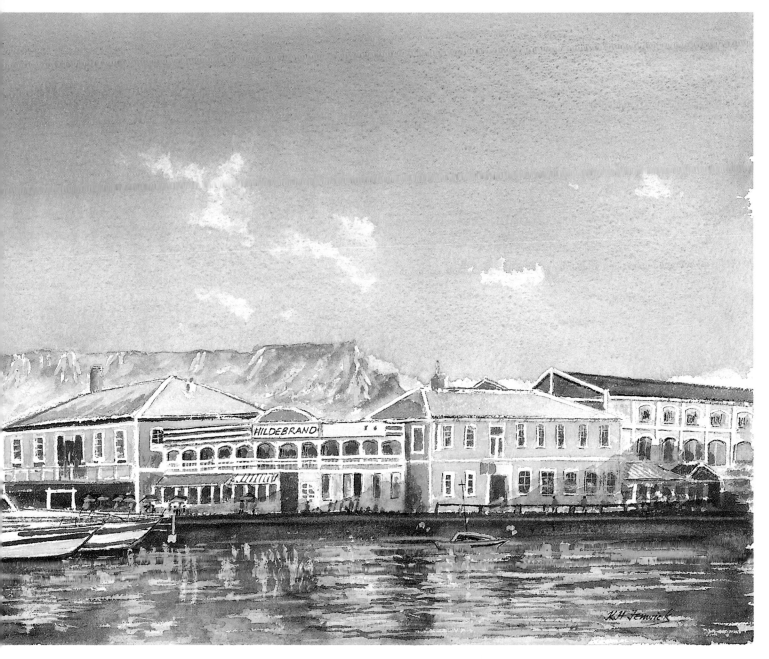

WATER AND DETAILS

Masking was initially applied to the water to represent light reflections. When the masking was dry, washes of Raw Sienna, Payne's Gray and Cerulean Blue were applied. The masking was removed when the paint was dry, and then a pale wash of Raw Sienna applied.

Finally figures were painted and the canopies coloured blue and green.

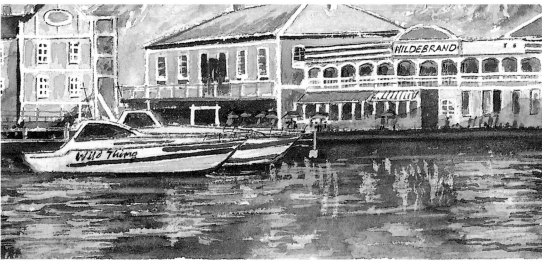

PAINTING BUILDINGS *Project*

The Grand Canal in Venice has been a favourite of artists over many generations. The most time-consuming aspect of this painting was the initial drawing of the buildings which I had to ensure were in proportion to one another. The many windows were also a challenge. I used the procedure outlined on page 12 to draw the scene.

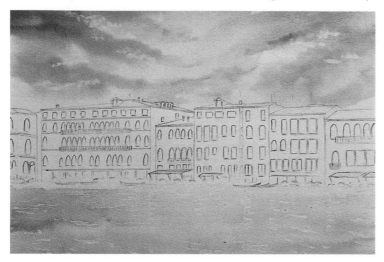

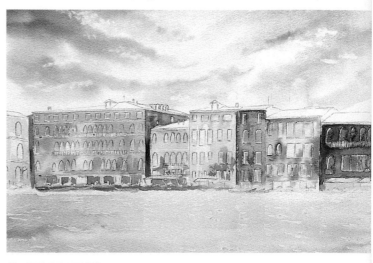

1. PREPARATORY DRAWING AND SKY

The waterline was drawn in followed by the verticals of the building, ensuring that the length of frontage of each building was in proportion to that of its neighbour. The height of each building was established in proportion to its frontage. The windows, balconies, canopies and parasols were drawn and masking fluid applied to maintain the white of the paper. Masking was also selectively applied to areas of the water.

The sky was painted using Payne's Gray, Raw Sienna, Alizarin Crimson and French Ultramarine. The same colours were used to paint the water as a mirror image.

2. BUILDINGS

Artistic licence was used to create warmer colours in the buildings than was apparent. Mixtures of Raw Sienna, Burnt Sienna and Alizarin Crimson were washed over the buildings, using a hake brush. Cobalt Blue was then dropped in here and there to indicate weathering. A Payne's Gray/Alizarin Crimson mix was used to paint in the shadows.

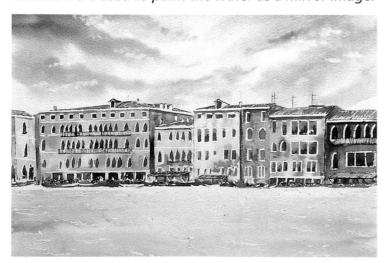

3. WINDOWS AND DETAILS

The roofs were painted using an Alizarin Crimson/Burnt Sienna mix. The windows were painted by applying various tones of a Payne's Gray/Alizarin Crimson mix. While the paint was still wet, a tissue shaped to a point was used to dab the windows, removing paint to suggest reflections of light. The same mixture was painted over the balconies. When this was dry the masking was removed, leaving white areas around the balconies and the windows. Next the masking was removed from the parasols and canopies prior to applying paint. The masking in the water was not removed at this stage.

The colours used

| Payne's Gray | Alizarin Crimson | Raw Sienna | Cobalt Blue | French Ultramarine | Permanent Sap Green | Burnt Sienna |

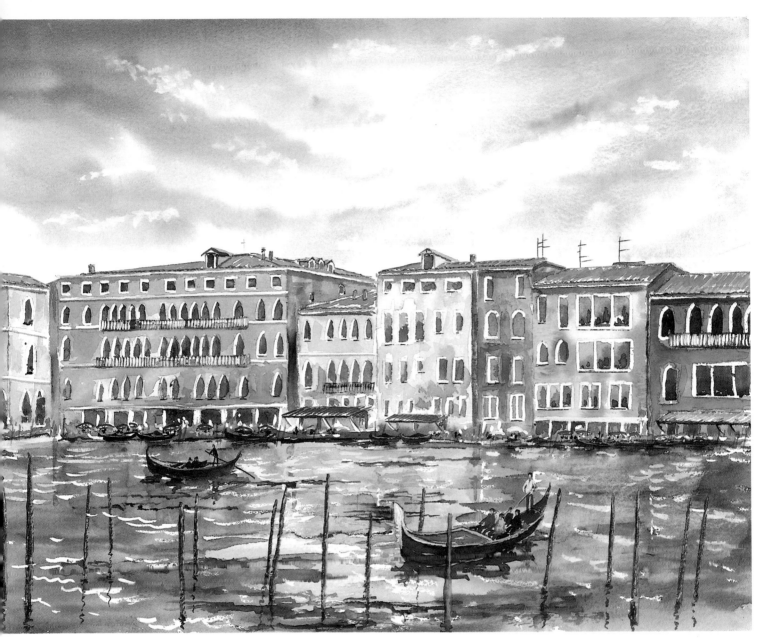

4. GONDOLAS

Before painting the gondolas I established their best positions by initially drawing their shapes with a felt-tip pen (water-based non-permanent) on a clear acetate sheet and then moving this over the water. Finally, the mooring posts were painted in.

5. WATER

The water was over-painted using a hake brush loaded with mixtures of Payne's Gray, Cobalt Blue and Permanent Sap Green. When the paint was dry the masking was removed using a putty eraser.

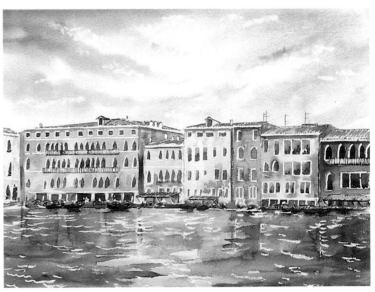

Decide on the statement you ar

I have painted this boathouse many times. Located on the shores of Lake Ullswater, in the English Lake District, it's a special place where I have spent many enjoyable hours. It's a very peaceful place to sit and paint. My favourite time is in the evening when the tourists have retired for their evening meal and I am left with a few swans or ducks for company. Acrylic watercolours were used for this painting, which was done for a TV programme.

After painting the sky and mountains, I painted the trees, boathouse and shore, leaving the water until last.

SKY

The sky was a feature in this painting. Using acrylic watercolours, I used a Raw Sienna wash and then, with a hake, brushed in Payne's Gray and Burnt Umber. When this was dry, I created the white edges to the clouds by wiggling the side of a size 14 round brush dipped in Titanium White.

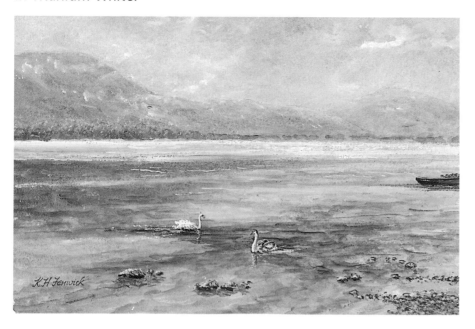

MOUNTAINS AND WATER

The mountains were brushed in with a hake brush after a piece of masking tape had been positioned across the painting to represent the waterline. Raw Sienna and Burnt Umber mixes were used and the row of distant trees was painted by adding a little Permanent Sap Green to the mixture. The masking tape was removed when the paint was dry.

Horizontal strokes with the side of the size 14 round brush were used to paint the reflections in the water over an initial Raw Sienna under-painting while this was still wet. A Payne's Gray/Cerulean Blue mix was brushed in to create variety in the water. The swans were painted last.

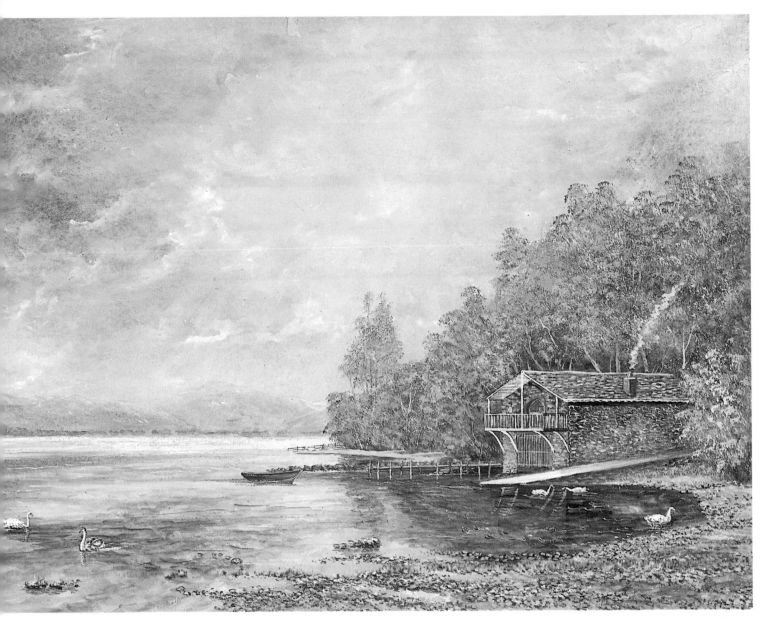

TREES

The trees were painted by initially applying a Burnt Umber under-painting around the drawing of the boathouse. Then I stippled a range of greens, using an old bristle brush, to create the impression of foliage.

BOATHOUSE

The stonework on the boathouse and access ramp was completed by applying a Raw Sienna wash and dropping in Burnt Sienna and Burnt Umber wet into wet. When this was dry, a rigger loaded with Titanium White was used to create the effect of mortar around individual stones. The balcony entrance and landing stage were then painted. Don't forget the fence in the middle distance; I painted this using a fine rigger brush. I used the same brush for the smoke from the chimney, painted in white over a Payne's Gray under-painting.

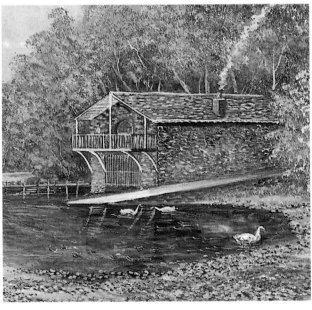

27

PAINTING BUILDINGS *Project*

I could not resist painting this beautiful Tuscan villa in watercolour. Constructed on a hilltop with magnificent views over the surrounding countryside and having many pleasing design features, it is one of the most impressive villas I have come across. I thought it would make an excellent exercise for a painting project.

I used artistic license to improve the composition, by adding the groups of trees. A 4B pencil was used to carefully make the outline drawing.

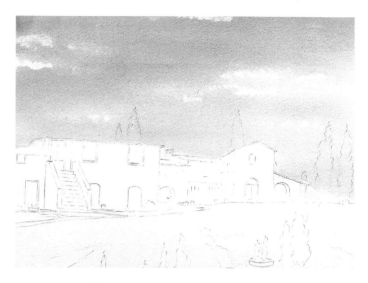

1. SKY

The simple sky was painted with a 1½ in hake brush. Graduated washes of Cerulean Blue were applied – darker tones at the top, becoming progressively paler as I worked downwards and added more water to weaken the mixture. The wispy white clouds were created by removing paint with a soft tissue using a dabbing action.

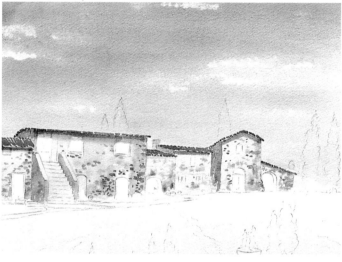

2. BUILDINGS

To represent the stonework, an initial weak Raw Sienna wash was applied using a ¾ in flat brush. I concentrated on one section at a time and while the wash was still wet brushed in some Burnt Sienna and a little Cerulean Blue, allowing the colours to blend together with the wet under-painting. When the paint was completely dry, I brushed in indications of stonework using a size 6 round brush.

The other half of the building was painted in the same way. The roofs were painted using a mix of approximately 20 per cent Alizarin Crimson and 80 per cent Burnt Sienna.

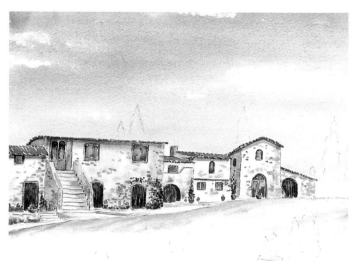

3. ADDING DETAILS

The next stage was to paint the windows and doors. For the windows, I used a size 6 brush loaded with a mix of Payne's Gray/Alizarin Crimson. While the paint was still wet, I dabbed at it with a tissue rolled to a point to remove colour. This technique absorbed paint, creating the atmospheric effect of light reflecting off the glass.

The doors were painted using a mix of Burnt Umber/Burnt Sienna. When this mixture was dry, I took a rigger brush loaded with Burnt Umber and using downward stokes represented the planks of wood that made up the doors. A soft green was brushed in to indicate vegetation at the base of the villa and a few plants growing in the terracotta pots.

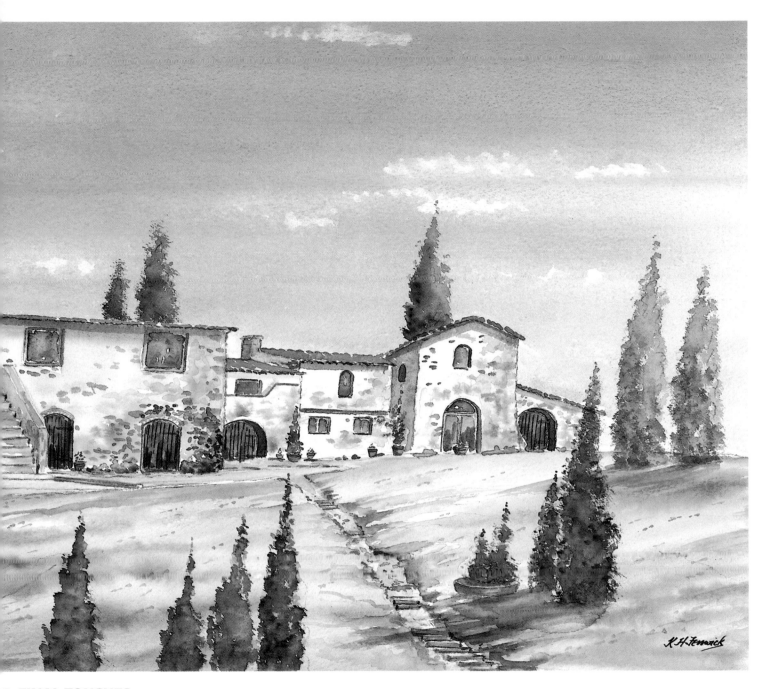

4. FINAL TOUCHES

The foreground grass was painted using a hake brush loaded with a variety of soft greens in varying tones, made from mixes of Cadmium Yellow Pale, Raw Sienna and Payne's Gray. When the paint was dry, I painted the path leading from the foreground to the villa using mixes of Raw Sienna /Burnt Umber.

Finally the trees were painted by stippling in mixes of Cerulean Blue and Permanent Sap Green with a ¾ in flat brush. Payne's Gray was added to the trees in the immediate foreground to give them dark tones.

The colours used

Payne's Gray	Burnt Umber	Raw Sienna	Cerulean Blue	French Ultramarine	Permanent Sap Green	Burnt Sienna

PAINTING BUILDINGS *Close up*

The 14th-century manor house at Lower Brockhampton, now owned by the National Trust, is a lovely old timbered building, with a detailed 15th-century gatehouse straddling the moat. I have included this scene as an exercise in drawing because it makes a pleasing composition and is useful practice for drawing and perspective. It's important to ensure the buildings are drawn in proportion and the perspective is accurate. Study the angles of the roofs and try to represent them accurately.

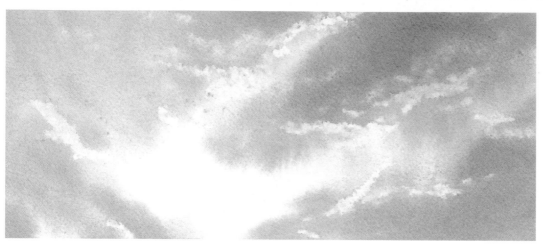

SKY

Remember the Golden Rule: a detailed foreground demands a simple sky. With this in mind a simple wet into wet sky was painted using Payne's Gray, Cerulean Blue over a Raw Sienna under-painting. A tissue was used to shape the cloud structures. The sky was painted using my 1½ in hake brush.

WATER AND FOLIAGE

The water was as usual painted in last using mixes of Payne's Gray, Cerulean Blue and Permanent Sap Green. Note the reflections from the trees and buildings. It's not necessary to paint a complete mirror image of the buildings, just include a few of the main factors to indicate reflections. Impressions of a few water-lilies were included. Note the variation in the foliage of the bushes and trees. An old bristle brush was used to create light areas of foliage and flowers on the bushes near the building, using a stippling action. To paint the lighter foliage, add a little white acrylic or gouache to your watercolour paints. If you do this the detail will stay on top of the under-painting, whereas traditional watercolour on its own will sink into the under-painting.

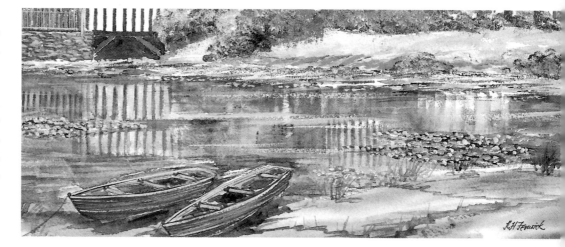

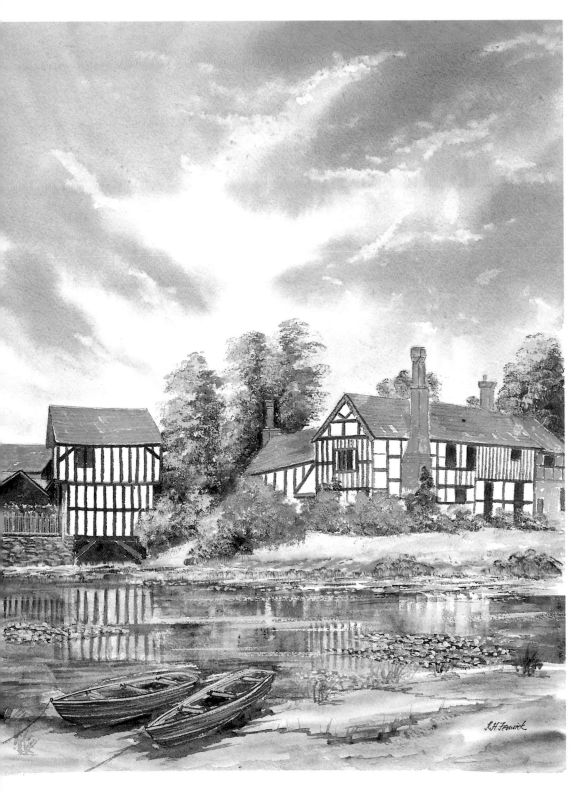

Checklist

• When painting buildings you will need to sit well back in order to fit in the number of buildings necessary to obtain a good composition.

• Never paint a building front on. You will need to sit slightly to one side to see some of the gable end. It makes a much more pleasing composition.

• Make sure you draw the perspective correctly or your painting won't look realistic.

• Squint your eyes when viewing – it helps to establish the light and dark tones and eliminate unnecessary detail.

BUILDINGS AND BANKS

A Burnt Sienna/Alizarin Crimson mix was used to paint the roofs, chimneys and brickwork. The extensive woodwork was painted using a Payne's Gray/Burnt Umber mix. Take care to ensure your perspective is correct. The windows were painted by applying a Payne's Gray/Alizarin Crimson mix and dabbing with a tissue to soften areas. To achieve gradation in the grass banks, I applied a weak Raw Sienna wash and brushed in a mid-green to selected areas, followed by darker green, brushing upwards from the water's edge. The colours will blend together, achieving a subtle gradation in the greens. If you over-do it, use a tissue shaped to a wedge to lift colour to create lighter areas.

PAINTING BUILDINGS *Project*

The old mill at Langstone in Hampshire, England was once a famous spot for landing contraband. It is now a peaceful haven for bird watchers and sailing enthusiasts. I think you will enjoy painting this scene.

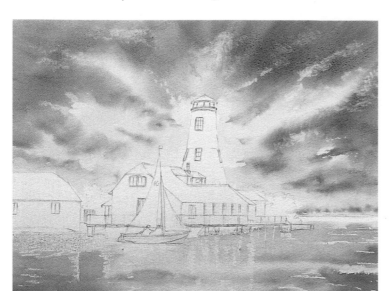

1. SKY

Care was taken to ensure the drawing was in correct linear perspective and each building was in proportion to its neighbour in terms of height, width and length. I commenced by drawing the right-hand group of buildings, making sure the mill tower was correct in diameter and height in relation to the building.

Masking fluid was applied to the windows, the railing and to highlight reflections and other areas in the water. The sailor and boat were also masked.

The sky was painted using a 1½ in hake brush and various mixes of Payne's Gray, Cerulean Blue and Alizarin Crimson over a Raw Sienna under-painting. Brush strokes were directed towards the mill tower. The same colours were used to paint the water.

2. BUILDINGS

A Payne's Gray/Burnt Sienna mix was applied to the mill tower and the dark areas at water level. A Payne's Gray/Cerulean Blue mix was used to over-paint the masking on the railings, the front of the pavilion and windows.

Approximately 20 per cent Alizarin Crimson and 80 per cent Burnt Sienna were used to mix a rich reddish brown colour for the roofs. The stonework was painted by initially applying a weak Raw Sienna and while this was still wet dabbing in some Burnt Sienna and Cerulean Blue, allowing the paint variations to blend together.

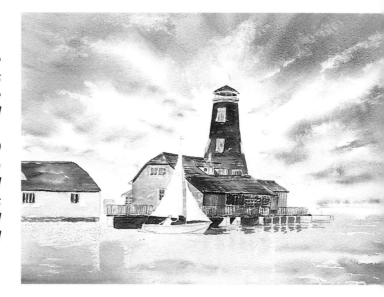

3. TREES AND WATER

The trees in the distance and middle distance were painted using a variety of light and dark greens made from mixes of Raw Sienna and Permanent Sap Green.

More depth was created in the water by applying various darker tones of a Payne's Gray/Cerulean Blue mixture, painting over the masking, which repelled the various washes. The brickwork supports were painted and using the same mix (Raw Sienna, Burnt Sienna, Alizarin Crimson) some reflections were painted in the water.

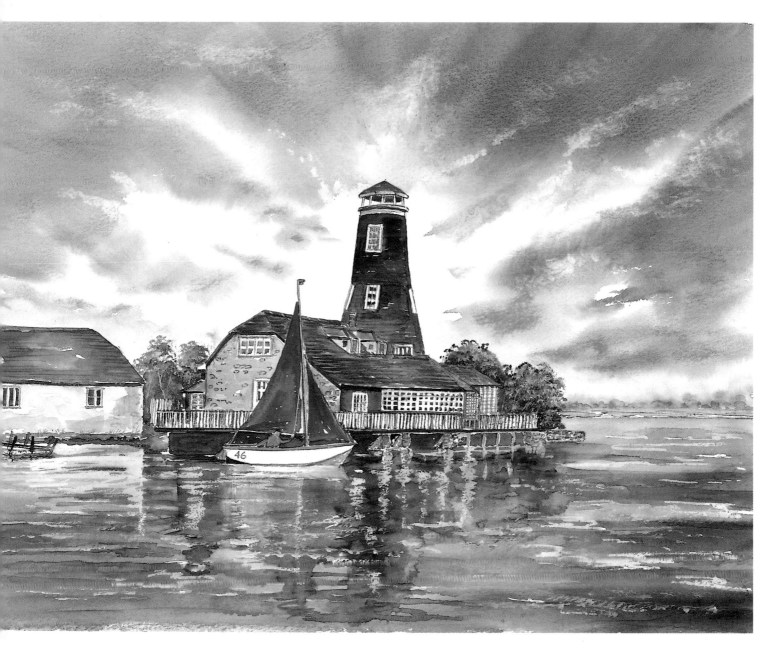

4. ADDING DETAIL

The boat was painted after removing the masking with a putty eraser and the sailor added using the rigger brush loaded with dark green. A few posts and the landing stage were painted on the far left using a Payne's Gray/Burnt Umber mix. Highlights were added to the water using a white water-soluble crayon.

The colours used

Payne's Gray	Burnt Umber	Raw Sienna	Cerulean Blue
Alizarin Crimson	Permanent Sap Green	Burnt Sienna	

PAINTING BUILDINGS *Close up*

Portsoy Harbour, on the north-east coast of Scotland, is a favourite location of mine, and frequently used by me and my students during painting holidays. There are myriad painting opportunities here.

When painting stonework, you have to use artistic licence to provide colour and variation to the buildings. If they are all a dull brown your painting will look drab and lack interest, so don't be afraid to drop in a few warm colours here and there.

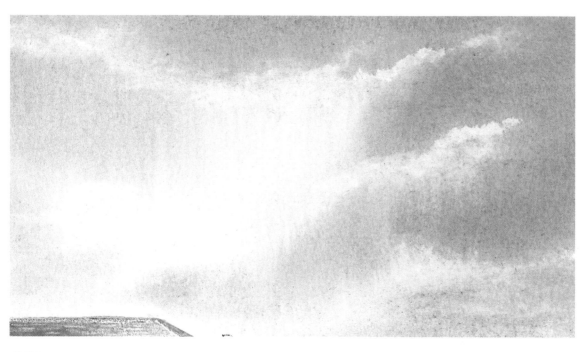

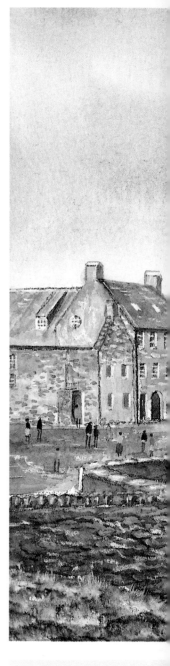

SKY

Remember the Golden Rule: a detailed foreground demands a simple sky; a simple foreground demands an atmospheric sky. In this painting the sky had to be simple because there is so much detail. I applied a Raw Sienna under-painting and while this was less than one-third dry painted in the clouds with Cobalt/Cerulean Blue. A few white clouds were formed using a tissue.

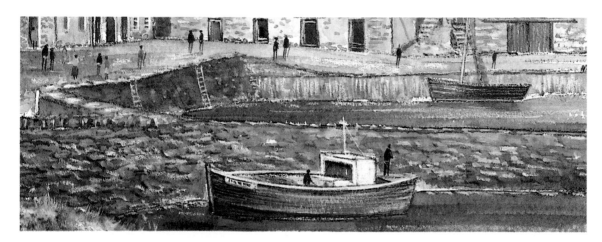

HARBOUR WALL

This part of the composition was simply painted by applying a Raw Sienna wash and brushing in a Payne's Gray/Alizarin Crimson mix to add darker tones. The effect of stonework in the wall in the foreground was created by moving paint with a palette knife – a very simple but effective technique. Using a softened white water-soluble crayon, a few highlights were created. Finally the fishing boat was painted.

Proportion

When painting buildings spend some time drawing them in proportion relative to each other. The simple stages to follow are shown on pages 12 and 13.

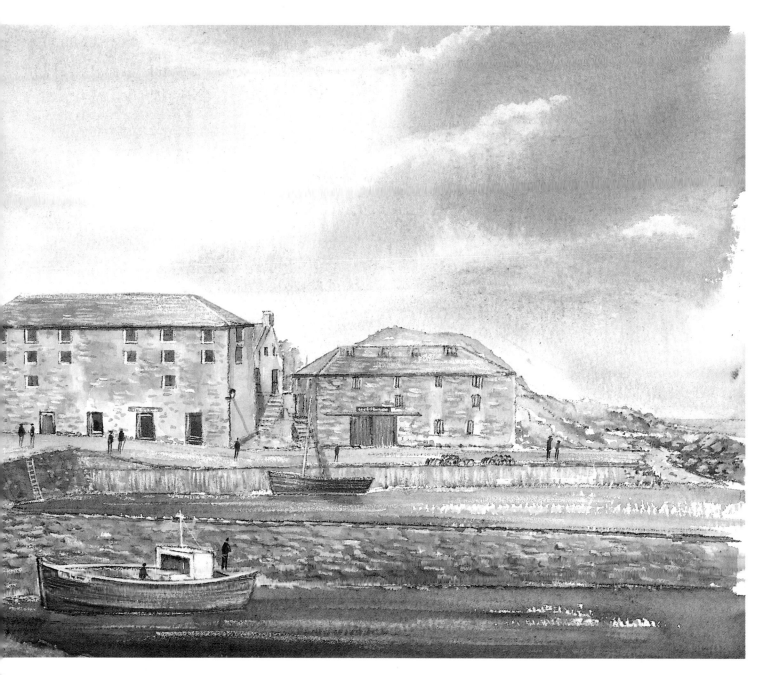

BUILDINGS, WATER AND DETAILS

To achieve variation in the stonework, Raw Sienna washes were initially applied. While these were still wet, Burnt Sienna and a Payne's Gray/Alizarin Crimson mix were brushed in to selected areas. There wasn't much reflected variation in the windows on this occasion.

The water in the harbour was painted with a mix of Permanent Sap Green and Payne's Gray using horizontal strokes applied with the side of a size 14 round brush. There were many visitors to the harbour on the day I was there, and so I added some figures to give life to my painting.

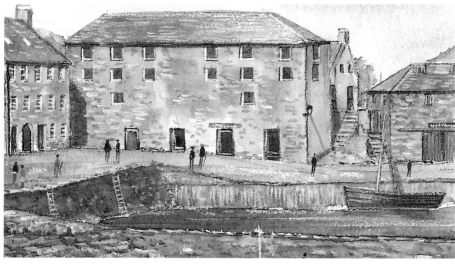

BRIDGES and WALLS *Introduction*

Bridges and walls are functional creations. Bridges are usually built to span a river or canyon, whereas walls mark out areas of land, such as fields and pastures, or the limits of somebody's territory. Bridges come in all shapes and sizes, in a variety of materials, from cut stone and brick to wood, concrete or iron. Generally speaking, walls and bridges made out of modern materials offer far fewer challenges to the artist, and it is for this reason I have concentrated on showing you examples made out of traditional materials such as stone. Many of these are works of art in their design, especially the stone bridges and walls found in country districts, where the traditions that go into their building are often closel associated.

Traditional bridges and walls offer artist wonderful opportunities to exercise their skills. Quit apart from their sheer beauty, they are master work of design and craftsmanship. Over the years I hav derived immense pleasure from painting them. I hop you too will be rewarded by seeing the workmanshi and ingenuity that has gone into their construction.

In the following pages, I'm going to show yo some helpful techniques and give you opportunitie to practise them. The colours I find most useful whe painting bridges and walls are shown below.

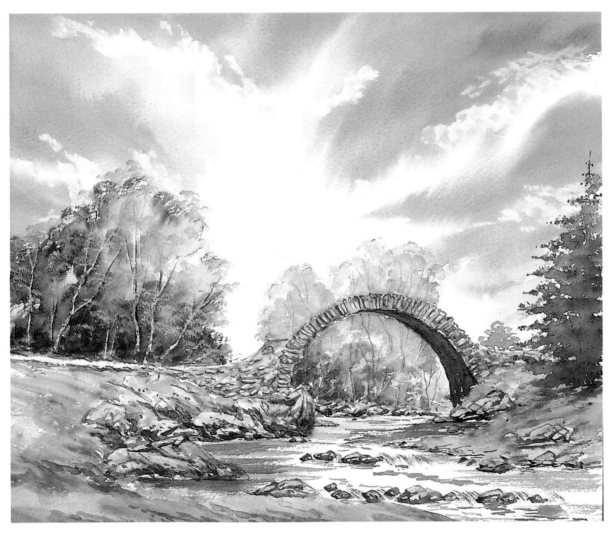

Wades Bridge is an unusual shaped bridge in Scotland. Almost a perfect semi-circle, it is a mystery why it neede to be built so high. Thi uncharacteristic shape i what is a picturesque setting inspired me to paint this scene.

The colours used

Payne's Gray	*Burnt Umber*	*Raw Sienna*	*Cobalt Blue*	*Alizarin Crimson*	*Burnt Sienna*

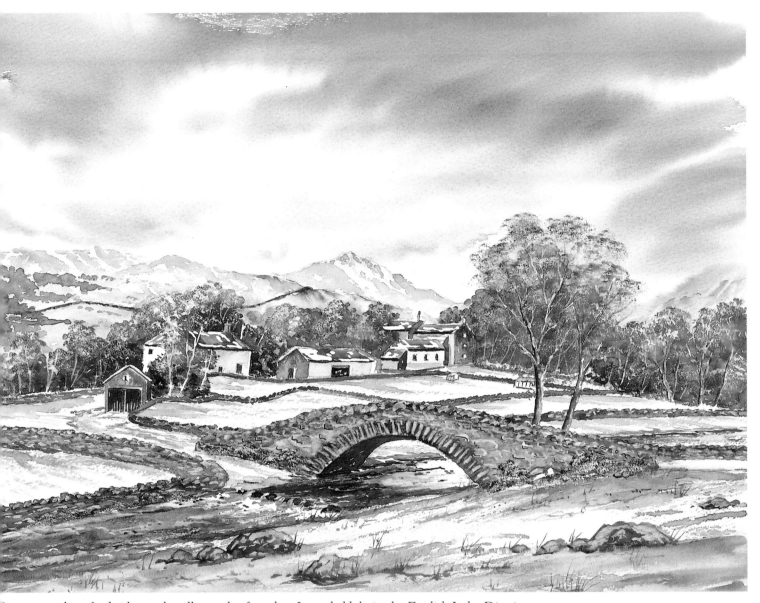

Fine examples of a bridge and walls can be found at Longsleddale in the English Lake District.

Points to remember

- *The structure is the starting point for any successful painting of a bridge or wall.*
- *Look for the small details that make each wall different. 'Hogg' holes, for example, are holes which allow yearling sheep, called 'hoggs', to pass through the wall to reach further grazing areas. Postboxes are often incorporated into a stone wall, and stone gateposts have holes which allow poles to be positioned across an opening instead of a gate. 'Rabbit snoops' for catching rabbits are built into some walls. Many ingenious practical devices are incorporated in stone walls. Look out for them.*
- *Each waller will use the type of stones available to him in the vicinity. As artists, we need to take this into account when painting stonework. If the walls are near a river the stones may be round, if near a quarry long and thin, so paint your wall accordingly.*
- *When painting bridges, try to select a viewpoint which enables some of the underneath of the arches to be seen. This makes a more pleasing composition.*
- *When incorporating stone walls in your composition, never paint them stretching from one side of your painting to the other without leaving an opening or incorporating a gate. Otherwise you are putting up barriers to the viewer and saying, 'Don't come into my painting.'*

PAINTING BRIDGES *Features*

I have chosen four attractive and interesting bridge styles for you to consider here, with a step-by-step diagram showing how to draw a simple bridge.

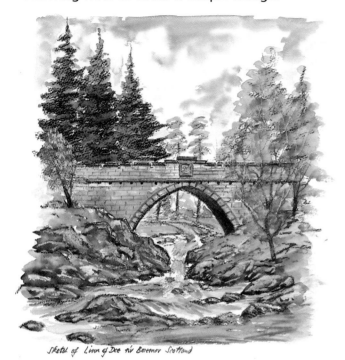

Sketch of Linn of Dee nr Braemar Scotland

I completed this quick demonstration sketch in water-soluble crayons when I was tutoring a painting holiday at Braemar in Scotland. The bridge is the famous Linn of Dee, a popular tourist attraction. Constructed from blocks of stone, it creates a pleasing, functional design over a gorge with fast-flowing water.

I used water-soluble crayons washed in with brushstrokes to create this simple representation. Water-soluble crayons are ideal for sketching and painting outdoors. I always carry a small tin of ten. This can be tucked into a pocket and all you need in addition is a brush to produce quick 'doodles'. The rocks were created by moving wet paint with a palette knife.

This bridge is typical of those found in many states of North America. They are simple, functional, wooden structures that are partially covered. Note the variety of colours used to paint the woodwork.

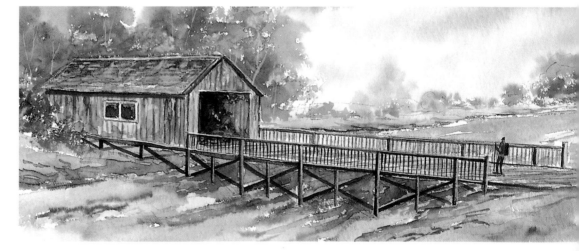

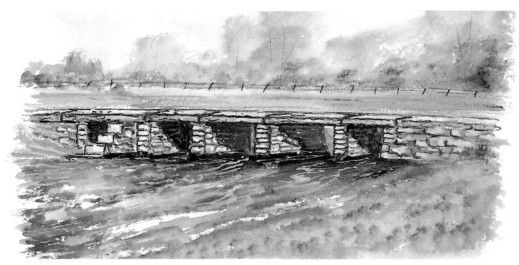

'Clapper' bridges are simple in form, crudely constructed and rough in appearance. They were one of the first types of bridge, made by placing large slabs of rock across a river or beck, and were used prior to the use of arches in bridge building. Examples can be found in most counties of England; this one is at Postbridge in Devon.

HOW TO DRAW A BRIDGE

Drawing a bridge can be very simple if you know the correct procedure – just follow the steps shown below.

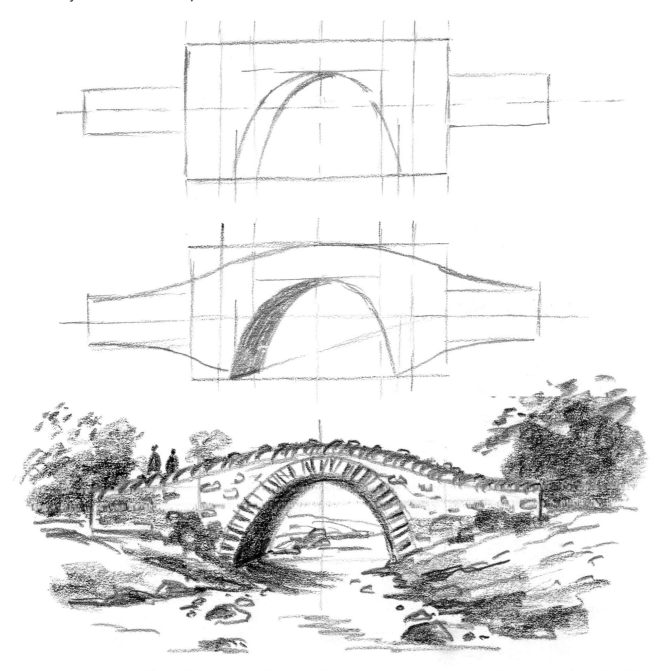

This simple river scene spanned by a bridge was drawn using the procedure shown above and described below.

1. Draw a rectangle. Divide the rectangle into four equal parts by drawing one vertical and one horizontal line through its centre.
2. Draw two further rectangles, one each side of the large one.
3. Divide the large rectangle into eight equal parts by drawing a vertical line in each half.
4. Divide each of the two outer areas of the large rectangle in two by drawing two further vertical lines.
5. Draw a horizontal line to represent the top of the arch by dividing the top area in half horizontally.
6. Draw two equally placed vertical lines to represent the width of the bottom of the arch.
7. Draw in the arch itself.
8. Draw in the general shape of the bridge. Note the angle at the base of the left side of the arch.

PAINTING WALLS *Features and textures*

A newly built stone wall is a pleasure to behold. Stone walls come in many imaginative designs, depending on the requirements and skills of the farmer, who will use the natural materials available to him. If the wall is near a river, rounded stones are used; if it is near a quarry, natural slivers of slate/stone may be chosen. The waller may incorporate flat stones and project them from the wall at various points to make steps which allow it to be scaled.

The techniques discussed here would also be used for painting bridges.

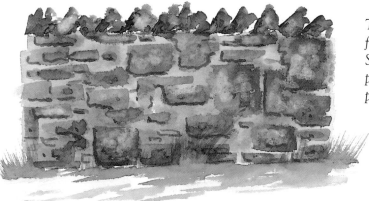

This wall has been built using large stones unearthed from land clearance. To capture it, I applied Raw Sienna wet into wet over a weak Payne's Gray under-painting. When this was dry, I used Burnt Umber to paint in the darker stones and shadows.

There are two interesting features in this wall: a hole, known as a 'hogg' hole (incorporated to allow young sheep known as 'hoggs' pass through), and a large stone which enables the gate to be fastened.

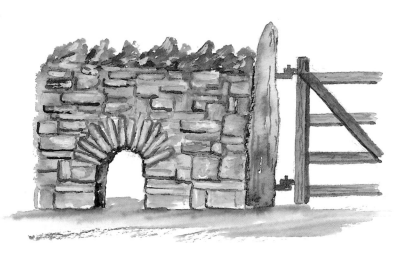

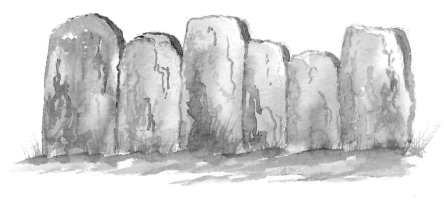

A 'flag wall' is created by positioning large stone or slate slabs in the ground. This type of wall is often seen around churches and gardens, or is used to denote boundaries. I used various tones of Payne's Gray to create texture.

For this brick wall I applied first a Raw Sienna/Alizarin Crimson under-painting and while it was still wet dropped in Burnt Sienna, Payne's Gray and Vermilion, allowing the colours to merge together. When the paint was approximately one-third dry, I used a tissue to create light areas on the bricks. When it was completely dry, I painted shadows along the left-hand and lower edges of each brick to create a three-dimensional appearance.

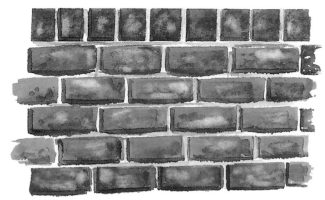

A palette knife helped me to create this painting of a stone wall. After applying a Raw Sienna wash I brushed in Burnt Sienna with dark tones of a Payne's Gray/Alizarin Crimson mix wet into wet. I waited until this was about one-third dry before moving the paint with the palette knife to create the stone structure and the coping stones.

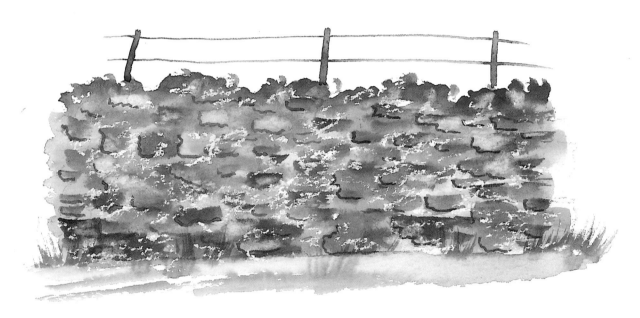

Watercolour and oil pastel can combine well to create texture. In this example the wall was painted initially with a cream-coloured oil pastel and then over-painted with watercolours. After applying the usual Raw Sienna wash, I used Burnt Sienna, Burnt Umber and a Payne's Gray/Alizarin Crimson mix, and when this was dry painted shadows on two edges of selected stones.

Useful colours for painting bridges and walls

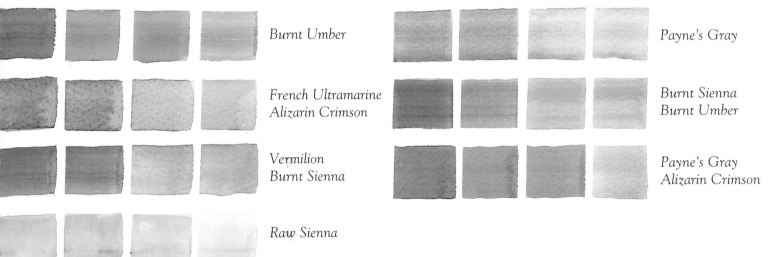

Burnt Umber

French Ultramarine
Alizarin Crimson

Vermilion
Burnt Sienna

Raw Sienna

Payne's Gray

Burnt Sienna
Burnt Umber

Payne's Gray
Alizarin Crimson

PAINTING BRIDGES *Close up*

This atmospheric scene was painted in acrylic watercolours at **Wasdale Head** in the English Lake District. The farmstead and lovely stone bridge make it a pleasing composition. In the background is Kirk Fell, its peak shrouded in low cloud, and next to it Great Gable, which is partly obscured behind the trees.

The public house in Wasdale is the 'gathering hole' for those setting out to climb either of these local land-marks. The well-worn track they take can be seen in the painting.

FELL AND SKY

In this painting I particularly wanted to capture the effect of the cloud around the top of Kirk Fell. The cloud was so low that the fell was barely visible. I painted the fell first, using directional strokes with a hake brush. After applying a Raw Sienna wash, and while it was still wet, I brushed in various greens, following the structure of the mountain. While the paint was still wet, I painted in the sky, allowing the paint to run over the top of the fell. With a tissue I removed paint to create the effect of cloud over the peak of the fell.

FOLIAGE AND FOREGROUND

The detailed bushes and specimen trees were painted by stippling in the dark under-painting, using a Payne's Gray/Permanent Sap Green mix. When this was dry, lighter groups of foliage were stippled in using an old bristle brush loaded with various tones of green.

The rough foreground was painted using the same techniques as that for the trees. When the paint was dry, a Raw Sienna/Burnt Sienna glaze (a small amount of paint and lots of water) was washed over the near foreground to add colour and sparkle. The grazing sheep were then painted.

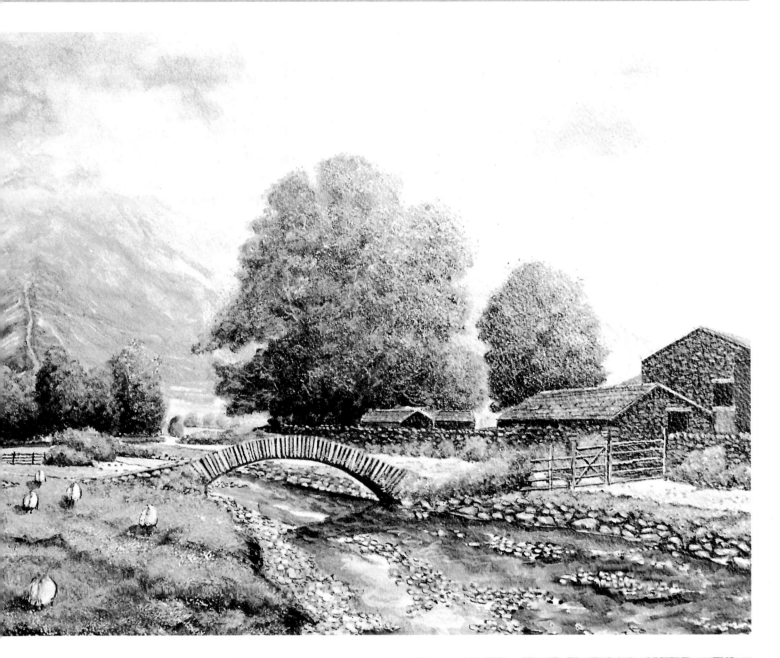

BRIDGE AND WATER

The bridge is very simple to paint, using angular strokes with a rigger brush. The colours used were Raw Sienna and Burnt Sienna, with Payne's Gray added for the shadows. Take care to ensure your bridge is a pleasing shape. Paint in a little of the underside of the bridge. The stones were painted using a size 6 round brush. and the water painted

using a Payne's Gray/Cerulean Blue mix, leaving areas of white paper uncovered. A hake brush was used for the water. When the painting was completed, a Raw Sienna glaze was selectively applied to areas on the fell, the distant fields, the trees and in the water – just small amounts here and there to add sparkle to the painting.

PAINTING BRIDGES and WALLS *Project*

Brougham Castle near Penrith in the English Lake District lies on the banks of the River Eamont. The castle was built between the 12th and 13th centuries. The sturdy stone bridge spanning the river provides a majestic foreground to the castle. The atmospheric sky and distribution of light over the castle walls and the fast-flowing water made the painting of this evening scene irresistible.

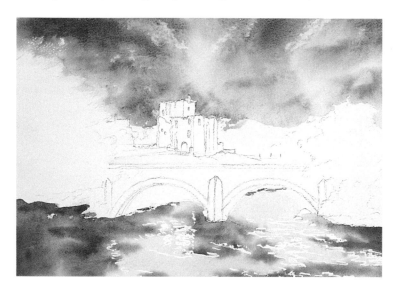

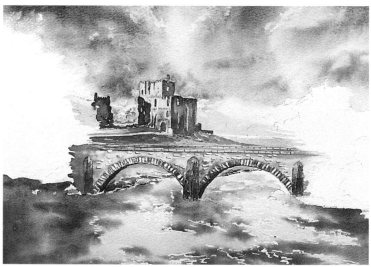

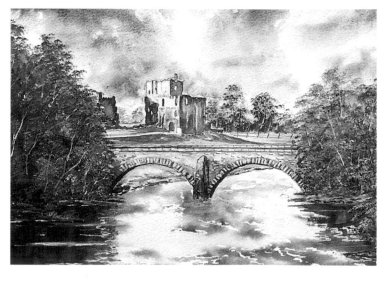

1. PRELIMINARIES

The outline drawing was prepared taking care that the correct proportions with regard to height and width of the castle were represented correctly. Similarly, the bridge structure was drawn, the width and profile of the arches being the most important considerations.

The sky is a special feature in this painting. An initial wash of Raw Sienna was applied using a hake brush. While this was less than one-third dry, the cloud structures were brushed in using mixes made from Burnt Sienna, Payne's Gray and Cerulean Blue. These colours were also used to paint the water. I took care to leave some of the paper uncovered to represent flow patterns and applied pale Raw Sienna washes to represent highlights on the water.

2. STONEWORK

The castle's stonework was painted by applying an initial pale Raw Sienna wash over all the walls, with small touches of Burnt Sienna brushed in while this was still wet. When dry a mix of Payne's Gray and Alizarin Crimson was used to paint the shadows on the castle walls, the profile of the windows and the arrow slits. The grass in the foreground was painted using a soft green, and the shadows painted taking care to leave the white of the paper uncovered to represent the track leading to the main gate. Similar colours and techniques to those for the castle's stonework were used for the bridge. When the paint was approximately one-third dry, a palette knife was used to scratch in the impressions of stonework. When the paint was completely dry the side and bottom of selected stones were darkened using a Payne's Gray/Alizarin Crimson mix to represent shadows.

3. TREES

The distant trees were painted next, using mixes of Raw Sienna, Permanent Sap Green for the darker tones. The foreground trees were similarly painted, using a stippling action with an old bristle brush. A few tree structures were scratched in with a palette knife and cocktail stick. Some darker tones were added to the water under the trees to give depth to the painting. A rigger brush was used to give fine detail to the fence in the distance.

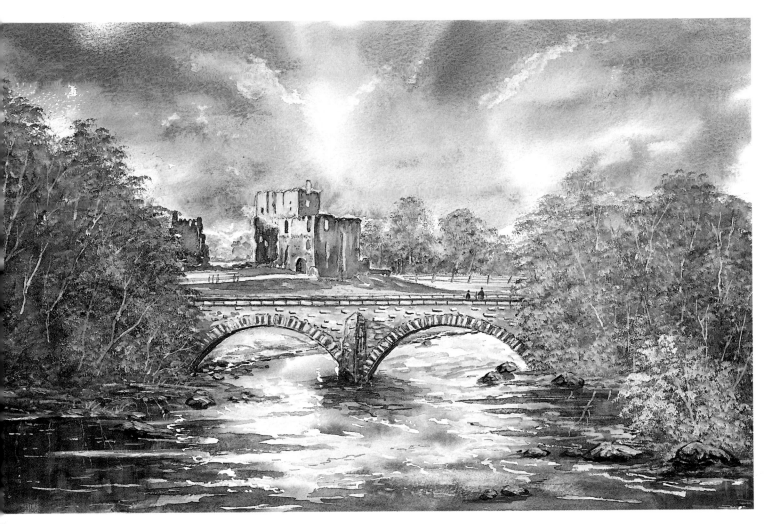

4. ADDING THE DETAILS

It's time to bring the painting together and add the finishing touches. Raw Sienna, Cadmium Yellow Pale and Burnt Sienna glazes were applied to the foliage and tree structures. These same glazes were also used to colour the rocks and create depth of tone.

Highlights to the foliage were then applied. Paper masks had to be first cut to shape to protect other areas, such as the sky; I used a piece of mounting card cut to various profiles to fit around the trees. To apply the paint, I took an old toothbrush, dipped it in Cadmium Yellow Pale, ran my thumb over the bristles and then spattered the colour onto the foliage.

Techniques and tips

• Masking is useful for protecting areas of white paper you wish to preserve. Over-painting will be repelled by the masking. Once the paint is dry, the masking is removed with a putty eraser.

• Wet into wet or wet into damp techniques are useful for textured effects.

• Rough-textured surfaces or flaking plaster are best created by blotting with an absorbent tissue or kitchen roll and using a rigger brush to paint in shadows, indicating the edge of the plaster and cracks in the surface.

The colours used

| Payne's Gray | Alizarin Crimson | Raw Sienna | Cerulean Blue | Cadmium Yellow Pale | Permanent Sap Green | Burnt Sienna |

Eilean Donan is Scotland's most recognizable castle and a source of inspiration for generations of artists. The castle has been a fortified site for at least eight hundred years, although the present castle was restored in the early 20th century. Eilean Donan and its magnificent setting attracts visitors world wide. The castle has been the venue for many films, notably *Highlander*, starring Sean Connery, and *The Master of Ballintrae* with Errol Flynn.

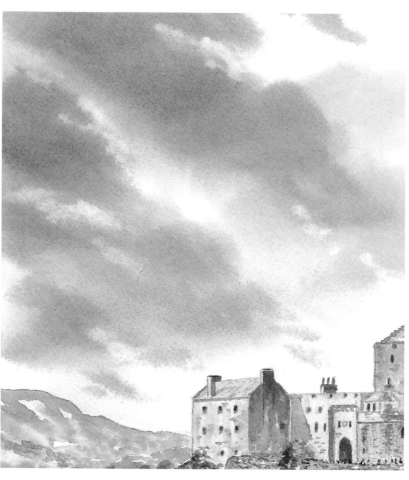

SKY AND MOUNTAINS

A piece of ¾ in masking tape was positioned across the paper to represent the water-line. The sky was painted using a 1½ in hake brush by initially applying a pale Raw Sienna wash and creating the cloud formations by brushing in mixes from Payne's Gray, Cerulean Blue and Alizarin Crimson. A tissue was used to soften cloud edges and create an interesting cloud study.

When the sky was dry, the distant mountains were painted using various tones of the same mixes used for the sky. When these were dry, the masking tape was carefully removed.

BUILDINGS AND WATER

I took care when preparing the initial outline drawing to ensure the buildings were drawn correctly. When painting buildings from a distance, I find the use of a small pair of binoculars invaluable. In this example, there are so many variations in the design of the building, I needed the binoculars to determine some of the features, particularly as the shadows, so important in this scene, tended to make observation with the naked eye difficult.

The buildings were painted by applying a Raw Sienna wash overall and brushing in a little Burnt Umber and a Payne's Gray/Alizarin Crimson mix.

The shadows were painted once the under-painting was dry, as were the windows and darker features. The tonal values of the shadows were important in this landscape.

Horizontal strokes with the side of a size 14 round brush were used to paint the water, with sparkle added by means of lighter touches. I painted the rocks after completing the bridge and water.

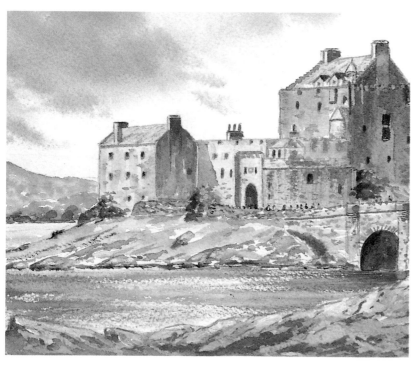

Tonal Studies

Use tonal value studies to determine your best viewpoint. These studies help to establish your values – lights and darks – prior to applying paint.

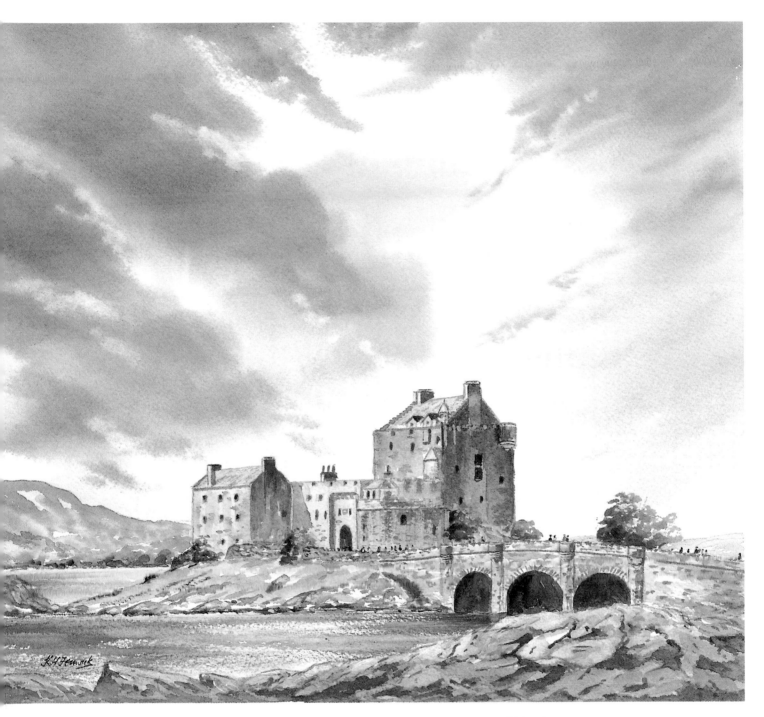

HE BRIDGE

rom my chosen viewpoint the arches of the bridge linking
he castle to the mainland had to be carefully drawn, as did
he supporting bridge, towers and buttresses. Care was taken
o observe and capture the shadows on the arches. The
ridge is quite simple in structure, but from my viewpoint it
vas a tricky exercise to draw, in particular its relationship with
he stone wall surrounding the path and leading to the castle
ntrance. The colours and techniques used were similar to
hose for the main buildings.

I added a few figures walking to the castle; at the time I
ainted the scene there were far too many people to include.

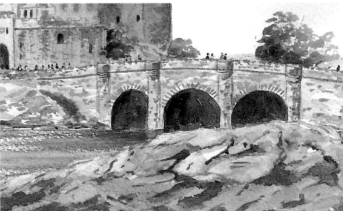

PORTRAIT OF THE ARTIST

Keith Fenwick is one of the UK's leading teachers of painting techniques. He enjoys a tremendous following among leisure painters, who flock to his demonstrations and workshops at major fine art and craft shows.

Keith is a Chartered Engineer, a Fellow of the Royal Society of Arts, an Advisory Panel member of the Society for All Artists and holds several professional qualifications including an honours degree. He served an engineering apprenticeship, becoming chief draughtsman, before progressing to senior management in both industry and further education. He took early retirement from his position as Associate Principal/Director of Sites and Publicity at one of the UK's largest colleges of further education in order to devote more time to his great love, landscape painting.

Keith's paintings are in collections in the United Kingdom and other European countries, as well as in the United States, Canada, New Zealand, Australia, Japan and the Middle East.

Keith runs painting holidays in the UK and Europe, seminars and workshops nationwide and demonstrates to up to 50 art societies each year. Keith can be seen demonstrating painting techniques at most major fine art and craft shows in the UK. He has had a long and fruitful association with Winsor & Newton, for whom he is a principal demonstrator.

Keith's expertise in landscape painting, his writings, teaching, video-making and broadcasting ensure an understanding of student needs. His book *Seasonal Landscapes* has proved very popular, as have his 20 best-selling art teaching videos, which have benefited students worldwide. He is a regular contributor to art and craft magazines.

Keith finds great satisfaction in encouraging those who have always wanted to paint but lack the confidence to have a go, as well as helping more experienced painters to develop their skills further. He hopes this series will be a constant companion to those wishing to improve their skills and experiment with new ways to paint the landscape.